ARIZONA PHOTOGRAPHERS
The Snell & Wilmer Collection

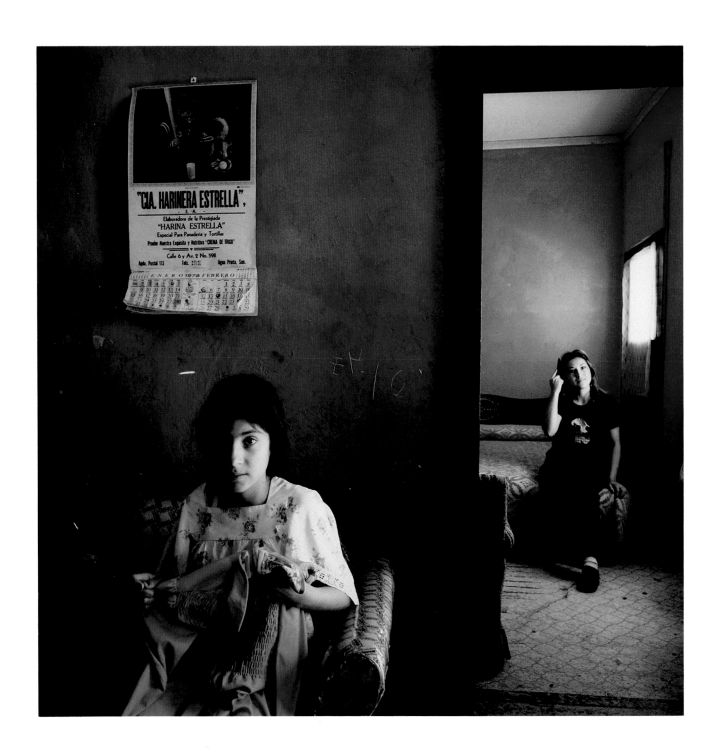

LOUIS CARLOS BERNAL: *Dos Mujeres, Douglas, Arizona,* 1978

ARIZONA PHOTOGRAPHERS
The Snell & Wilmer Collection

Essay by Terence Pitts • Foreword by Edward Jacobson

Center for Creative Photography • The University of Arizona

Center for Creative Photography
The University of Arizona
Copyright © 1990
Arizona Board of Regents
All Rights Reserved
ISBN 0-938262-19-X

Designed by Nancy Solomon
Typography by Typecraft
Separations by American Color
Printed by Classic Color
Bound by Roswell Bookbinding

FRONT COVER: *Encounter* © 1986 Lorne Greenberg
BACK COVER: untitled © 1987 Barbara Gilson

Snell & Wilmer is a law firm
with offices in Phoenix and Tucson,
Arizona, and Irvine, California.

EXHIBITION SCHEDULE (to date)

The Complete Collection

Center for Creative Photography
The University of Arizona
March 11 to April 15, 1990

Phoenix Museum of Art
August 17 to November 18, 1990

*Arizona Commission on the Arts
Traveling Exhibition*

Coconino Center for the Arts
Flagstaff, Arizona
January 11–February 17, 1991

Houston Center for Photography
April 5 — May 5, 1991

Yuma Art Center
September 6–October 31, 1991

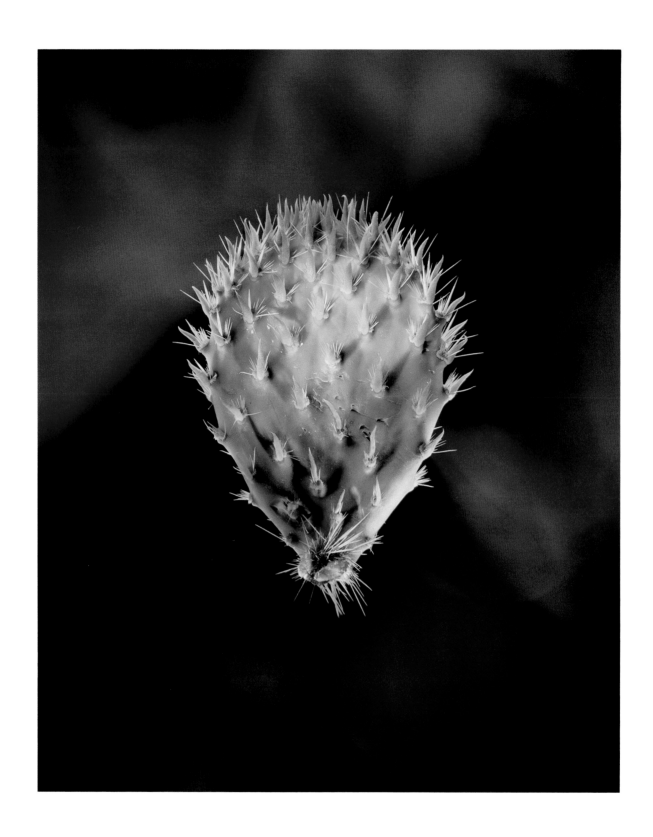

WILLIAM LESCH: *Young Prickly Pear Pad, Blue/Red*, 1988

Foreword

by Edward Jacobson

IN THE FALL OF 1984, SNELL & WILMER'S PHOENIX LAW OFFICES took on an added floor and in the fall of 1987 still another. At first the walls on each were bare. And, while providing art for offices has itself become a recognized profession, the firm has long looked to a partner for nearly forty years (the writer) to perform this function.

One hundred seventy-six photographs later taken by forty-seven Arizona photographers, now hang on those walls. What is the verdict? Does the audience enjoy the work? I think so.

The receptionists tell me they hear many comments, mostly favorable. Some of the lawyers and support personnel have begun to include photographs among other works of art in both their homes and their offices. And, a few have seriously begun to collect photography.

Soon, however, a more reliable test of approval will occur. All of the pictures will be off the walls for five or six months while they are being shown, first at the Center for Creative Photography in Tucson and then later at the Phoenix Art Museum. After that the Arizona Commission on the Arts will tour a group of these pictures both in and out of the state for another year or so. Will the pictures be missed or only the fact that the walls are bare, resented? My guess is some of each.

Why, four years ago, were Arizona photographers chosen as the art category to be collected by the firm? It would seem to be a much more obvious choice today than it was then. Today, as the art press and even the daily papers tell us, photography is "hot" and "in." Being the one hundred and fiftieth anniversary of photography, 1989 saw an unprecedented number of major photography shows opening across the nation.

In 1985, however, photography was not particularly sought after on the art market. Prices were not inflated and fine works were available for purchase. The works of Arizona photographers seem to be appropriate to where we live and work. It appeared that no one was collecting in this field. Such a collection could be unique. The quality of light in Arizona together with the state's scenery, its population mix of old-timers and newcomers, Native and Spanish American peoples, and even a few remaining cowboys, provided picture-taking opportunities that attracted the best of photographic talent. In short, high quality photographic art was available. In addition, the Arizona photographers take diverse approaches

7

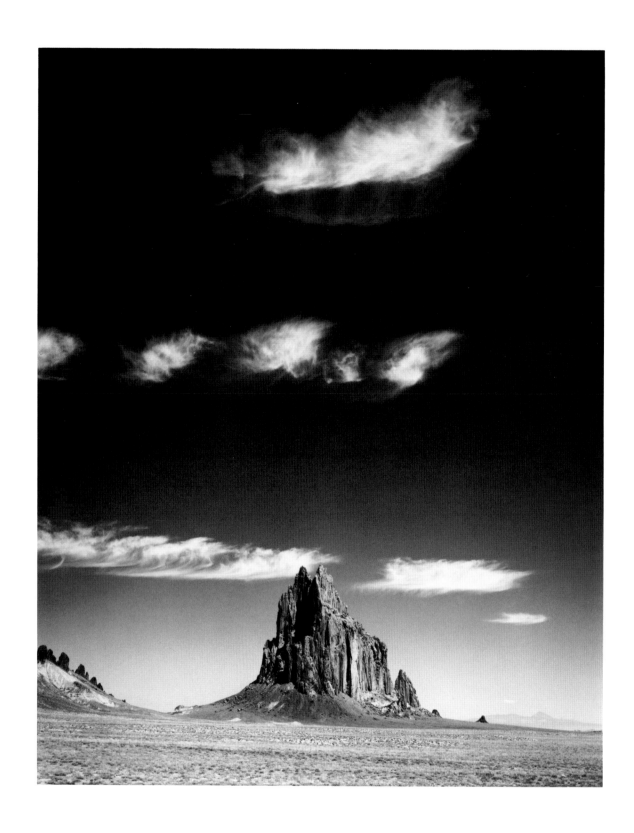

JODY FORSTER: *Shiprock, New Mexico*, 1979/89

in method, nature and style of work. They present, in fact, a broad statement about photography in general — with a western accent. Thus, they seemed to be a good choice for an audience with a wide range of tastes and interests.

While it will take some years to determine whether better choices could have been made, at least for the present it would appear that the selection of Arizona photographers was not a mistake. It might even be a winner.

ASSEMBLING THE COLLECTION HAS BEEN A CHALLENGE and a great learning experience but it has not been difficult. In the main, the fine photographers of this state are intensely aware of their peer group. Short lists from each one resulted in a core list of most of them. The first credits, therefore, must go to the photographers themselves for leading the writer from one to the other and, therefore, for the overall quality of the collection.

Next, in terms of importance, was the advice rendered by James Enyeart, Director of the International Museum of Photography at George Eastman House, who, at the time the collection was being assembled, was Director of the Center for Creative Photography. When the collection was nearly complete, he surprised and pleased the photographers, the writer, and the firm by extending the Center's invitation to catalog and show the work.

A necessary predicate to this invitation were the approvals and concurrences of Terence Pitts and Nancy Solomon, the Center's Director and Publications Coordinator, respectively.

Thanks is also extended to James Ballinger, Director; Bruce Kurtz, Curator of Contemporary Art; and Karen Hodges, Assistant to the Curators at the Phoenix Art Museum, whose combined enthusiasm for the collection resulted in the Phoenix Art Museum's offer to show the collection as well.

Appreciation to Shelley Cohn, Director of the Arizona Commission on the Arts, for her conviction that the quality of the work of the Arizona photographers justified a Commission plan to travel a group of these pictures not only in Arizona but also to other states.

Encouragement and direction came from two of the State's pied pipers of photography, Rudy Turk, Director of Collections at Arizona State University, and Terry Etherton, co-owner of the Etherton/Stern Gallery in Tucson.

Additional thanks are owing to Corinne Cain, the firm's curator and appraiser; Sheri Manoukian and Derek Peterson of Gallery Three who helped frame and hang the works and to my secretary, Linda Winter, who, somehow, kept track of all this activity.

Finally, my great appreciation to Snell & Wilmer, the law firm of which I have been a part for these many years, for encouraging me in this project, never once asking that any choice be reviewed, and for enjoying the result.

9

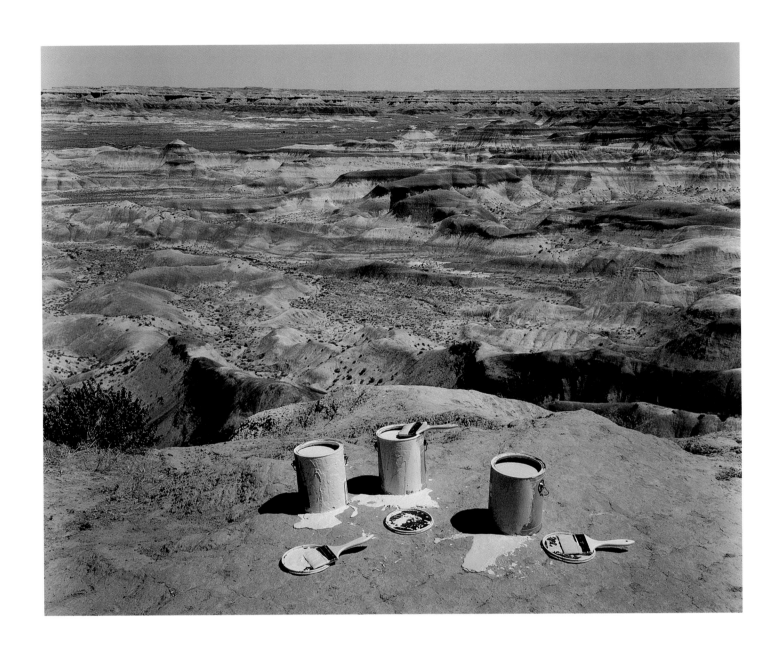

TAMARRA KAIDA: *Desert Paint*, 1987

Arizona Photographers
The Snell & Wilmer Collection

by Terence Pitts

THE SNELL & WILMER COLLECTION OF ARIZONA PHOTOGRAPHERS represents a strong and visible commitment to contemporary photography. In addition to providing an excellent overview of the medium in our time, it makes a statement about Arizona's place in the ongoing history of photography. The forty-seven photographers in this collection represent nearly every style being practiced in contemporary photography, from the traditional to the postmodern. Many of the names in the collection are recognizable to followers of photography far beyond the borders of the state.

The support that Snell & Wilmer's collection gives to Arizona photographers is an example of American business patronage at its best. The selections were made by one of the firm's senior partners, Edward Jacobson, a man for whom building important collections has been a passion for years. And because acquisitions were made according to his taste and connoiseurship, the collection contains works not only by well-established figures in photography but young and unknown artists as well.

Especially exemplary is Snell & Wilmer's commitment to the public. Nearly all of the collection hangs in public view in their Phoenix headquarters. It hangs there to be seen and discussed, not just admired. It hangs there to educate the senses and the aesthetic spirit about the power and diversity of contemporary photography. Snell & Wilmer's willingness to let its walls be stripped bare so that their collection can be shown at the Center for Creative Photography and the Phoenix Art Museum is a testament to their public commitment, as is their enthusiastic cooperation in letting the Arizona Commission on the Arts subsequently tour a selection from the collection.

Collections are, by definition, bound to structures, limitations, goals. The Snell & Wilmer Collection is a representative group of works produced, with a few exceptions, in the nineteen eighties by Arizona photographers. But from the outset, Jacobson realized that the structure of the collection he was assembling had to be flexible. Some of the photographers — like Dan Budnik and Canadian-born Lorne Greenberg — were peripatetic, living only part-time in Arizona, while traveling or living elsewhere much of the year. Other photographers — like Lawrence McFarland and David Muench — have since departed the state for new jobs, new opportunities, new adventures. As this essay is being written, several

11

more of the photographers represented in this collection are moving out of Arizona, just as new ones are moving in. No doubt Jacobson will get around to meeting them before too long.

TO ARIZONA AND THE WEST, LANDSCAPE IS BOTH GIFT AND BURDEN. Since the era of Carleton Watkins, Timothy O'Sullivan, and William Bell over a century ago, the geography and geology, the flora and fauna of this region have attracted photographers like a supermagnet. Nowadays, for better and for worse, coffee-table books on the western landscape are as prolific as tumbleweed. The West's extraordinary natural monuments have been so frequently, variously, and dramatically depicted that a wisecrack abounds that there is little point in visiting the Grand Canyon because it looks so much better in photographs.

As a result, photographers smitten by the western landscape and determined to capture the drama of land, sky, and light skirt deliberately and dangerously near the edge of cliche. But as the Snell & Wilmer Collection demonstrates, landscape remains a flourishing and dominant motif, continuously open to new discoveries and insights.

In a state experiencing the rapid growth and suburbanization of its major metropolitan areas, the photographer often plays the dual role of modern explorer and concerned environmentalist. Jody Forster's landscapes, especially his *Weaver's Needle, Superstition Mountains, Arizona*, 1980, transform the land into hero-icized, sometimes threatening forms, contrasted by the ephemeral, poetic clouds overhead. In these images of uninhabited wilderness, nature is depicted as far more powerful and more poetic than anything humankind could build.

An intriguing comparison can be made between Forster's photographs and those of Lawrence McFarland. McFarland's two images are also landscapes with clouds, but here the moody, transience of the sky dominates the almost tender landscape. The lone yucca plant in his *White Sands, New Mexico*, 1981, and the wind-blown wheat in his *Wheatfield*, 1976, seem slightly anthropomorphic, giving his images the feel of Whitmanesque odes.

In two of his photographs, James Cowlin used a panoramic format camera to complement the wide horizons of the Grand Canyon, and he, like many recent landscape photographers, has turned to color photography to capture the fleeting colors of the season and of day and night. Jerry Jacka is another photographer who often photographs the transitory Arizona storms and skies, yet he also manages to turn these moments into events that stand outside history.

Dick Arentz's photographs, printed on sheets of paper that Arentz himself handcoated with a combination of platinum and palladium salts (as opposed to the silver salts of most black-and-white photographs) represent a fusion of art and craft. After considerable experimentation, Arentz found the proper integration of

12

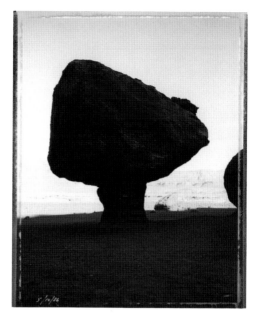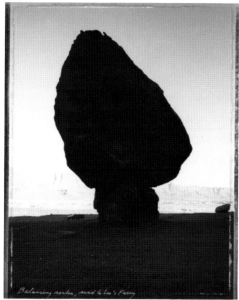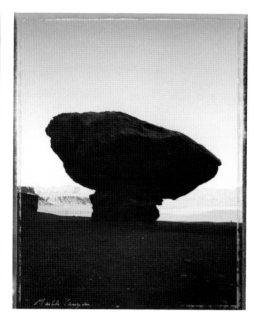

MARK KLETT: *Balancing Rocks, Road to Lee's Ferry, Marble Canyon, Arizona, 5/10/86*

paper and photosensitive materials to give his photographs the crisp, full to-nalities in keeping with the visually rich landscapes to which he is attracted. His *American Southwest* portfolio includes not only pure landscape photographs, but also some images of rural towns and ancient habitations, suggesting a western ecosystem based on small populations living in close contact with nature.

The photography of Mark Klett serves as a direct, innovative, respectful, and yet sometimes ironic link to the classic photographs taken in the West during the 1870s and 1880s. His photograph *Balancing Rocks, the Road to Lee's Ferry, Marble Canyon, Arizona*, 1986, is a take off on one of the more famous nineteenth-century photographs of Arizona, William Bell's *Perched Rock, Rocker Creek, Arizona*, 1872, only Klett has indicated scale by substituting a modern pickup truck for the soldier sitting beneath the perched rock in Bell's version. Klett's panoramic polyptych *Around Toroweap Point Just Before and Just After Sundown Beginning and Ending with a View by J. K. Hillers, Over One Hundred Years Ago, Grand Canyon*, 1986, incorporates in the two end panels the same vantage points used by Hillers, who photographed for John Wesley Powell's Geographical and Geological Survey of the Rocky Mountain Region. Klett's three middle panels document the section of the canyon that Hillers omitted as well as capturing the gradual setting of the sun in the process.

In a corner of the country where landscape has become a principal form of photographic enterprise, it is logical that new approaches to the genre would flourish. Some of these new approaches are variants of the traditional landscape photograph, while others deliberately seek to undermine a tradition that, in addi-

tion to many masterpieces, has produced so much kitsch and copycat art. Arizona, with its cinematic history of cowboys and Indians and its full roster of widely recognized emblems — like the everpresent saguaro cactus — seems particularly vulnerable to caricature, deliberate overstatement, and subtle irony.

One example of the way that landscape can be undermined is to attack the very words by which the landscape is known, as in Tamarra Kaida's tongue-in-cheek *Desert Paint*, 1987, which plays with the clichés of landscape rather than ignoring them.

One widely used strategy in the battle to reform landscape photography has been to redefine landscape as the total environment we live in — the natural and the humanmade, the pristine and the ravished. There seem to be two main, underlying motivations to this approach to landscape photography. The first is to suggest that the totally natural landscape has become for most people a myth rather than a reality — a very powerful myth with strong nationalistic overtones that presents a dangerously unrealistic vision of the status of the natural world around us. The second motivation is a restorative one — common throughout the history of American art — which suggests that the humanmade landscape — now sometimes called the social landscape — has a kind of beauty all their own and that we overlook them at some risk.

In both Harold Jones's photograph *With Emmett*, 1978/86, and Billy Moore's *Boca Chica, Brownsville, Texas*, 1987, empty, forlorn highways blend with the landscape in an homage to the American love of the road. The American road is not only a symbol of personal freedom, but also of our wanderlust and our need for renewal by nature, even if it is a nature laced with highways and strung with power lines.

Joe Labate's photograph *Tucson, Arizona*, 1986–87, is a wry, even ironic view of the way in which the blending of the real and the humanmade has transformed and falsified the American landscape. The clouds, the mountains, and the carefully placed palms are real, while the immensity of the swimming pool, crowded with onlookers ogling a bikini-clad girl, was intentionally meant to suggest a beach or lakeside setting to the minds of water-deprived desert dwellers.

IN A GENRE THAT STANDS HALFWAY BETWEEN LANDSCAPE AND STILL LIFE ARE close-up images of nature, such as Charles Braendle's photographs of sand dunes, which are reminiscent of similar images made by Weston in the thirties. Braendle has pushed his sensual images nearly into the realm of the erotic by stressing the dunes' texture rather than their formal or abstract potential. John Mercer's *Sand Dunes, Death Valley, from Three Feet*, 1981, projects us into a world of sculptured sand devoid of scale (except for the work's title), while his *Frosted Creek, Cave Creek*, 1985, turns frost-tipped plants into delicate, luminescent patterns. Dana

14

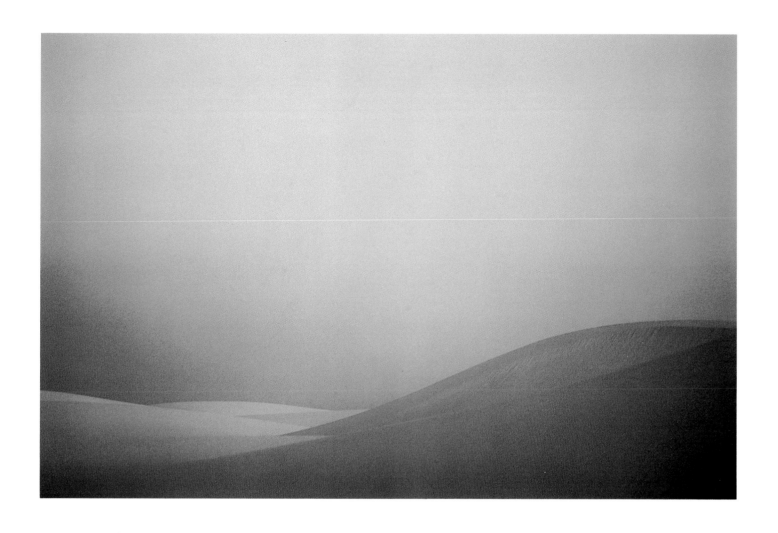

CHARLES BRAENDLE: *White Sands, New Mexico*, 1983

Slaymaker achieves a similar visual and tactile sensuality in a color photograph, *Pond Surface, Sabino Canyon*, 1985/1989, an image of color and light without any apparent substance.

The photography of plant forms is a tradition that goes back to photographs of cacti and succulents made by Imogen Cunningham and Edward Weston during the nineteen twenties and thirties. In shifting from the geological to the bibliogical, these images do more than call attention to the life at our feet rather than the distant horizon and sky, they substitute delicacy and pattern for the chaos and immense power so apparent in the western landscape. They return us to human proportions and time frames measured in years rather than millenia. These plant forms almost seem to belong more to the world of mathematics and engineering than to that of weather and history.

Barry Thomson's suite of photographs *From Out of the Desert*, made in Phoenix's Botanical Gardens, are precise yet mysterious photographs that allow us to hover over and around the architecture of some of the regions most stunning plants. In the most complex of these photographs — his subtly lit images of succulents — Thomson balances the soft, water-swollen flesh of the plants with the knife-like edges of their thorns.

Keith Schreiber's *Agave*, 1985, and Jack Dykinga's *Agave Leaves, Baja, Sierra San Borja* approach the very same subject matter with different results. Schreiber's black-and-white image is a menacing study of a single, flame-like leaf, while Dykinga has created a symphony of brilliant desert colors.

Several photographers represented in the Snell & Wilmer Collection are more concerned with the colors of their imagination than the colors of the desert around them. William Lesch creates a desert painted with fantastical colors by adding to the natural colors of desert scenes, flowers, and cacti artificial colors projected across his subjects using lights and colored gels.

Todd Walker uses the processes of silkscreen and offset lithography to print images in a breathtaking array of ink colors, resulting in color relationships that are as beautiful and striking as they are unnatural. Although Walker has been manipulating color in this fashion since the sixties, it has only been during the past few years that there has been widespread interest in altering this aspect of the medium. More and more photographers are now working on the basis that nothing in their medium need be sacred and that photography can concern itself just as successfully with fictions as with truths.

Linda Fry Poverman's *Cabbage II*, 1987, is a Van Dyke brown print hand-colored with Prismacolor pencils. The Van Dyke process gives a soft, warm brown-toned image that provides a base for Poverman's careful application of rich colors. While the finished image does not seem glaringly wrong to our eyes, the colors that Poverman includes are subjective — not at all the real colors of a natural cabbage.

PHOTOGRAPHS BY RUTHE MORAND, MICHAEL BERMAN, AND DAVID MUENCH serve as a natural bridge between landscape photography and another important concern of southwestern artists — Native American culture. The integration of the natural world and the native cultures of the Southwest has been a compelling motif for American artists throughout this century, ranging from artists such as Georgia O'Keeffe and Ansel Adams to Robert Smithson and Linda Connor.

In Ruthe Morand's photographs, landscape is given human meaning through petroglyphs that have been left behind. Western artists have always been fascinated with petroglyphs, not only for their artistic beauty and spiritual significance, but also for the fact that they are painted or carved directly on the landscape itself. Her *Gila Cliff Dwellings, New Mexico*, 1982, depicts the landscape as seen from the perspective of an occupant of the dwelling.

Michael Berman's two small prints depict an iconic, mystical West. The sites that Berman photographs seem to be places of spiritual, even ritualistic importance to him. In *Canyon Lands, Utah*, 1987, a male figure gives scale to the cliff in the photograph and seems to represent the modern enchantment with ancient religions. The odd-shaped, lone mountain in *Shadow Mountain, Utah*, 1987, suggests a kind of natural Stonehenge.

Like Morand, David Muench, in his photograph *Anasazi Petroglyph, San Francisco Peaks, Arizona*, places us directly inside the landscape as a way of trying to bridge centuries and cultures in order to place us inside the culture of those who created the powerful petroglyphs within sight of the San Francisco Peaks of northern Arizona.

Photographs by W. W. Fuller and Rita Lee concentrate on the architectural details of southwestern pueblos, which have long been admired by non-Native American artists for their simplicity, functionality, and directness. The way that light interacts with adobe, stone, and wood has attracted many photographers throughout this century. Fuller's *Church, Laguna Pueblo, New Mexico*, 1982, is a classic image in this genre. The effects of sunlight on the adobe structure emphasizes both the repetition of architectural details and the irregularities of the handcrafted materials.

Equally architectural is John Running's *Teepees — Rocky Boys, Montana*, 1978. This is the architecture of nomadic people, rather than pueblo dwellers, but, like Morand, Running's vantage point among the teepees right at sunset positions the viewer more as an insider than an outsider to this world.

Through hand-coloring, Lee imaginatively adds subtle southwestern colors to her photographs. In keeping with the educational nature of this collection, Snell & Wilmer also acquired Lee's preliminary, uncolored prints to show what her images looked like before the hand-coloring.

John Schaefer's portfolio *Bac* contains fourteen images of perhaps the finest example of mission architecture extant in the United States, San Xavier del Bac,

17

completed in 1797 just south of Tucson. Though the religious sculptures that Schaefer photographed are almost pure Spanish in style, the overall architecture and many of the mission's details are a Spanish Colonial style modified noticeably by New World influences. Schaefer's attention to detail and to the complex, ever-changing perspectives that a visitor has of the mission serve as an homage to the anonymous architect and craftsmen that preceded two centures earlier.

In a series of works that combine historical photographs of Phoenix with recent photographs made of the same location, Allen Dutton brings architectural photography into the present. Dutton's rephotograhic survey of downtown Phoenix graphically depicts the radical changes that the city has undergone in less than a century. Depending on one's view of progress, Dutton's witty, often humorous comparisons evoke hope or despair.

Jeffrey Matthias's precise photographs of the Valley National Bank Building (where the Snell & Wilmer corporate offices are located), are, like Dick Arentz's photographs, printed on a paper made of a mixture platinum and palladium. In Matthias's case, this gives his images not only a remarkable repertoire of detail, but also a substantial, gritty surface that mimics the actual texture of the building.

PORTRAITURE HAS ENJOYED A STRONG RESURGENCE in the eighties. Much of this activity has portrayed the diversity of the American people, frequently cultures outside what is considered the mainstream of American society. Photography as a whole seems to be responding to the Anglo-centrism and xenophobia latent in our culture and to the homogeneity of American culture as depicted in the popular media. One also has a strong sense of the criticism of American society embedded in photographers' fascination with cultures that have traditions seemingly capable of resisting change altogether or absorbing change slowly, almost meditatively. In Arizona one is reminded daily that we live at a cultural crossroads, where numerous peoples and traditions coexist simultaneously, and this has long been one of the most appealing facets of this region for artists.

Barry Goldwater's portraits of Navajos, which date back to the nineteen thirties, are the earliest photographs in the Snell & Wilmer Collection. Published in issues of the magazine *Arizona Highways* and in his book *Face of Arizona*, Goldwater's images provide a historical glimpse at what has long been the second most popular genre (after landscape) of photography in Arizona — cultural portraiture. They represent the long-standing tradition of photographers, such as Timothy O'Sullivan, Edward Curtis, Adam Clarke Vroman, and many others, of depicting Native Americans sympathetically within the backdrop of their own culture and landscape.

Al Abrams's photographs of people from the Pima, Apache, and Papago (now Tohono O'odam) tribes typify the more recent approach to cultural portraiture,

18

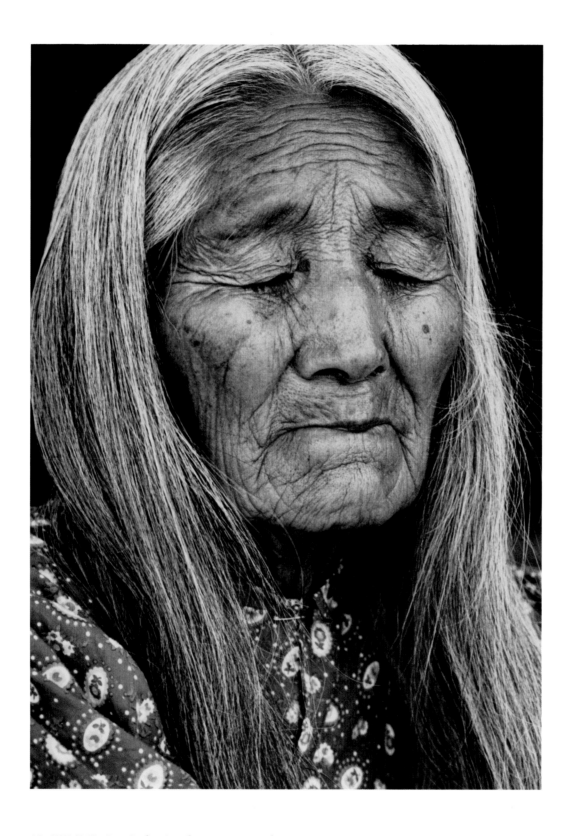

AL ABRAMS: *San Carlos Apache Woman, Peridot, Arizona, 1973*

allowing the realities of modern life to temper the idealized representation of other cultures that confront us daily in the form of such things as tourism campaigns and music videos.

Louis Carlos Bernal's sensitive photographs of the interiors and residents of barrios in Texas and Arizona use color as a strong cultural element. Bernal's images seem to be portraits of a culture slowly evolving across the generations right before our eyes, and the thick interiors of the barrios seem to be metaphors for their communities' resistance to the pace of life elsewhere.

Similarly concerned with the traditions and symbols of Hispanic culture is Robert Buitron. The figure in *Adolfo, Zapote de Peralta, Mexico*, 1980, holds in his hands portraits of his father and his mother, while in *Las Veronicas, Phoenix, Arizona*, 1987, we see two young women wearing skirts decorated with depictions of flamenco dancers. Perhaps purposefully, the context and symbols of the next generation, represented by a young boy in *Joseph, Nuevo Laredo, Tampico, Mexico*, 1980, are omitted.

Jay Dusard is represented in the Snell & Wilmer Collection by photographs from two projects: *La Frontera*, a study of the Mexican-American border, and *The North American Cowboy: A Portrait*. In his photographs, people's faces seem marked by years of contact with adobe, sun, and harsh landscape. These formal, elegant images with their emphasis on textures and strong light approach the territory of sculpture.

In a somewhat lighter vein is Hal Martin Fogel's photograph *Big Shirley on Her Wedding Day, South Mountain*, 1977. Big Shirley stands husbandless and railed in on top of a rocky overlook, reminiscent of the decorative bride that traditionally stands atop a wedding cake.

Other artists have always been popular subjects for the photographer's camera, and the Snell & Wilmer Collection contains several examples of such portraits. Bill Jay's portrait of photographer Todd Walker is part of an ongoing series of informal portraits that Jay, a photographic historian, has been making of the photographers that he knows and meets, thus creating an archive of images that provide flesh and context to contemporary photography.

In contrast, Dan Budnik's portrait of Georgia O'Keeffe is a classically formal study of an artist surrounded by art (one of her ceramic pieces and an Alexander Calder mobile). Budnik's subtle handling of color, light, and texture echo the central characteristics of O'Keeffe's paintings and pottery.

In a way, the artist's self-portrait is a variation of the portrait of the artist. The possibilities for revealing or concealing personalities, for theater, for fact or fantasy, are essentially the same. In Judith Golden's Magazine Series, 1975, the artist herself appears in nine different guises. Golden used photography to give her the opportunity to try on for size, so to speak, images of women from popular magazines. These rich images manage to simultaneously contain two seemingly con-

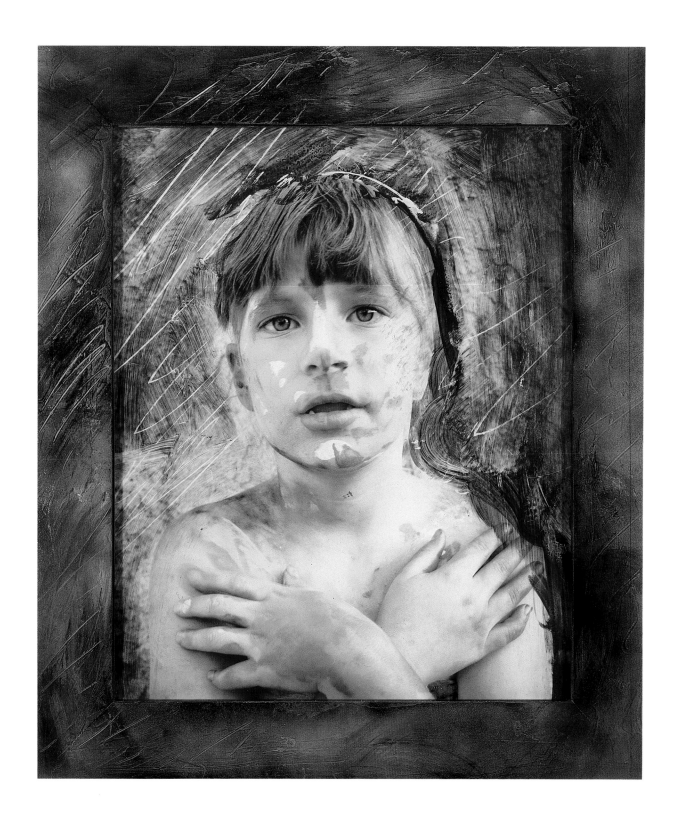

JUDITH GOLDEN: *Persona XV*, 1985

tradictory artistic stances. On the one hand, we witness the artist's ability to fantasize and metamorphose into the features of other women, and, on the other hand, these images suggest a critique of the image of women commonly depicted in advertising and fashion.

In *Persona XV*, Golden uses a child model to create a haunting character right out of the world of myth or fairy tale. The child's face, the backdrop, and even the frame have been painted, removing any traces of time or place, leaving the child in a primeval state.

Frances Murray's two untitled photographs from the Dream Cards series, 1980, also use children as figures of innocence. Are the children dreaming? Is the artist dreaming of children (in this case her own children)? We are presented with a beautiful enigma.

There is something frightening and malevolent, however, in Tamarra Kaida's three images of children from her Fairy Tales series. Kaida has depicted these children as haunted, bereft of innocence, perhaps even resentful of what the photographer herself has made them do in the name of art.

Although her photographs are less specifically about children, Barbara Gilson's work does dwell on the subject of childhood. By using a plastic Diana camera that produces images of very poor resolution and even some optical distortion, Gilson rejects the traditional strengths of photographic optics in her search for a more impressionistic way of photographing children jumping down sand dunes and inner tubing down a river.

Lorne Greenberg uses double exposure to create impressions of a different sort. While Gilson seems to suggest the time warp that occurs when an adult overlays her own past onto the activities of other children, Greenberg's double exposures of public murals and street scenes from Mexico and Tucson's barrios suggests the blur and confusion of a visitor to another country and another culture, as well as the relationship between popular history and contemporary life.

In a way, Eric Kronengold's untitled photograph from 1969 of a zoo gorilla and the shadows of its human onlookers is also an image about the disjuncture that results where two worlds meet — in this case in the zoo, where animal and human creatures come together in a staged, yet often uncomfortable relationship.

Ambiguity and inner emotion are the subjects of James Hajicek's photograph from the series *To Fall in Darkness: Gifts of Suffering/Gifts of Rejoicing*, 1988, which consists of an image of barbed wire and a flare of light across a sky. Probably the most famous historical antecedents for this photograph are a series of photographs of clouds made by the American photographer Alfred Stieglitz about seventy years ago. Stieglitz called this his "Equivalents" series because, untethered by any social meaning, these almost completely abstract photographs of clouds drifting across the sky could evoke the contemplativeness, turmoil, anxiety, and exhilaration of human emotion.

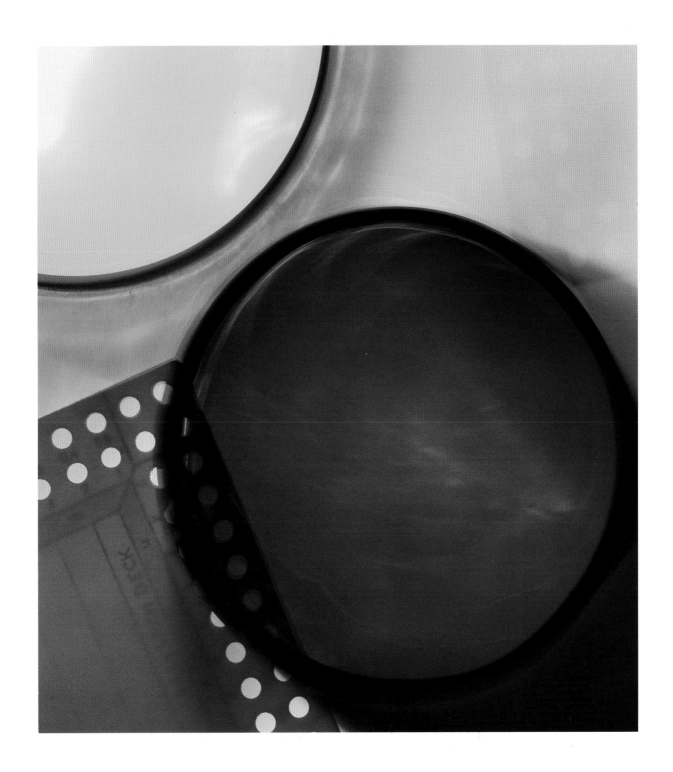

ROXANNE MALONE: *Geometric Series, #4*, 1983

Several photographers represented in the Snell & Wilmer Collection have created works that border on pure abstraction. Made using Kirlian photography, three color photographs from Roxanne Malone's "Geometric Series" combine mathematics, science, and art to create works of great visual intensity and beauty. Ann Simmons-Myers' *Koi*, 1988, and *Minnow*, 1988, are both made using the gum-bichromate process, which causes the layering effect that suggests fish and other objects submersed in water. Like Malone, Simmons-Myers uses a process that allows color to dominate the image.

Kenneth Shorr's *Still Life*, 1988, was made using a 20 by 24-inch Polaroid camera. The dark, menacing, abstract shapes in his image suggest vandalism or natural destruction, a far cry from the usual connotations of the still life genre.

Two photographers use the techniques of surrealism to create still lifes of enigmatic meaning. The title of Camille Bonzani's *Particular Moon-X*, 1988, only serves to stress the ambiguity of the relationship between the egg, the pedestal, and the leg in her photograph. David Elliott's *King Casper*, 1989, presents an ironic, encapsulated, puppet-like head of former Secretary of Defense Caspar Weinberger.

The remarkable diversity of the photographs in the Snell & Wilmer Collection is one clear indication of the high quality of photographic activity in Arizona today. In part, this reflects the current vitality of photography in this country. But Arizona has always attracted photographers for its landscapes, its light, and its cultures. Add to this developments such as the *Arizona Highways* publication, an institution like the Center for Creative Photography, and important and lively photography programs at the states' universities and colleges, which have attracted nationally recognized faculty and creative students.

PORTFOLIO

ROXANNE MALONE: *Geometric Series, #3*, 1985

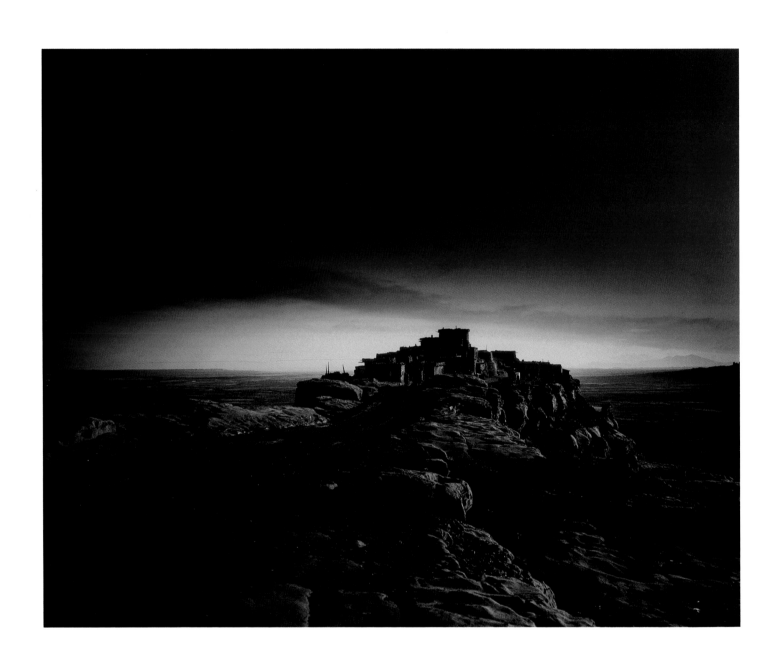

JERRY D. JACKA: *Walpi Sunset (Hopi Reservation)*, 1974

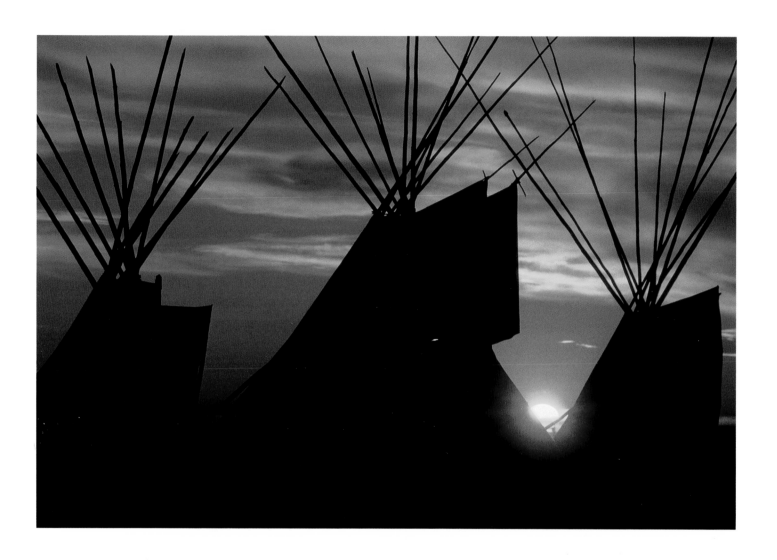

JOHN RUNNING: *Teepees — Rocky Boys, Montana, 1978/88*

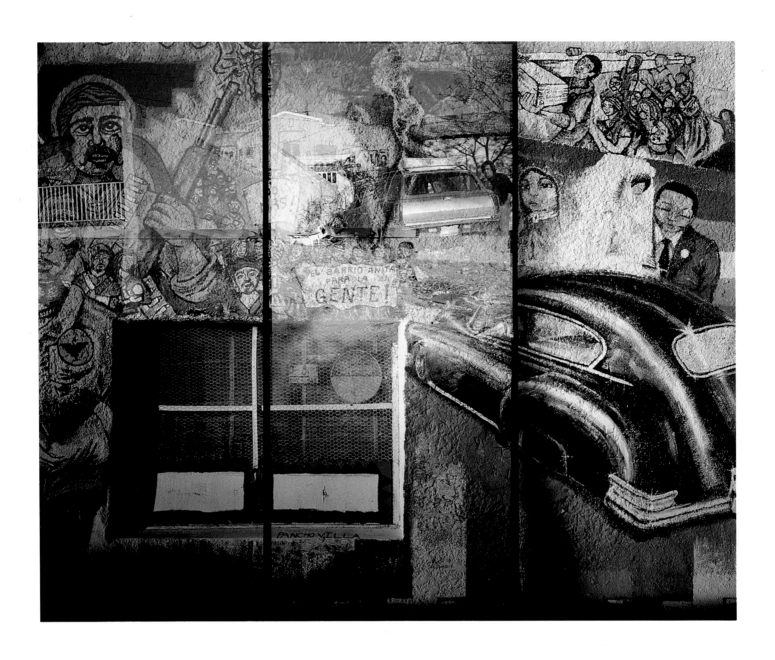

LORNE GREENBERG: *Wedding*, 1986

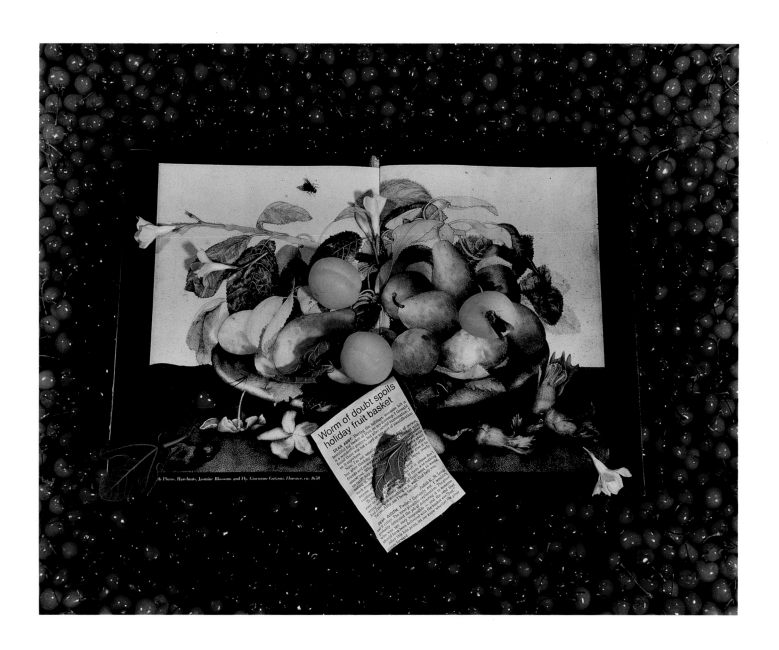

TAMARRA KAIDA: *Worm of Doubt*, 1987

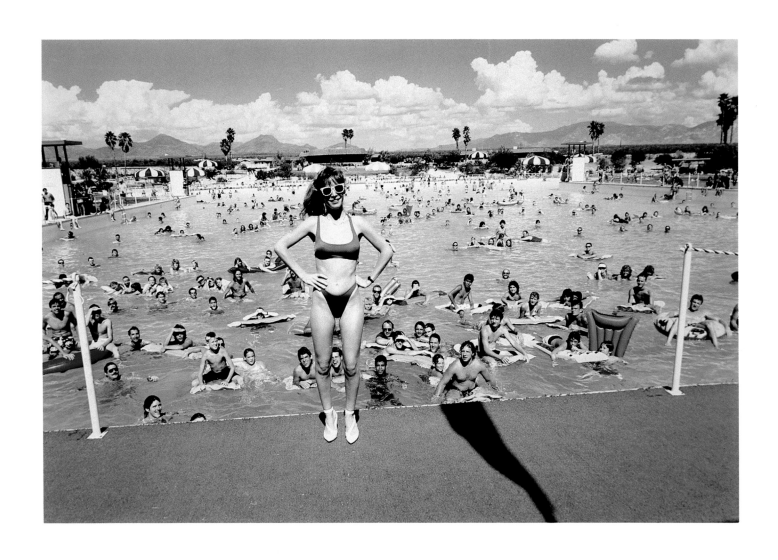

JOE LABATE: *Tucson, Arizona,* 1986

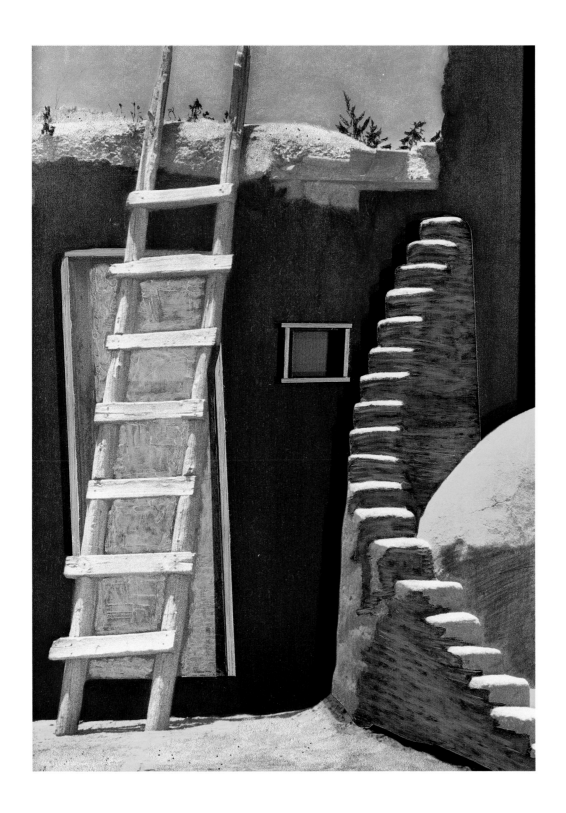

RITA LEE: *The Pueblo — Carved Stairway*, 1986

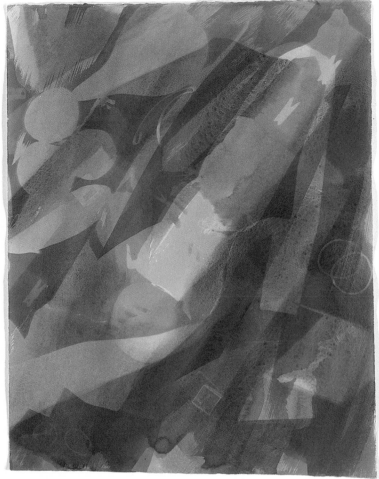

ANN SIMMONS-MYERS: *Minnow*, 1988

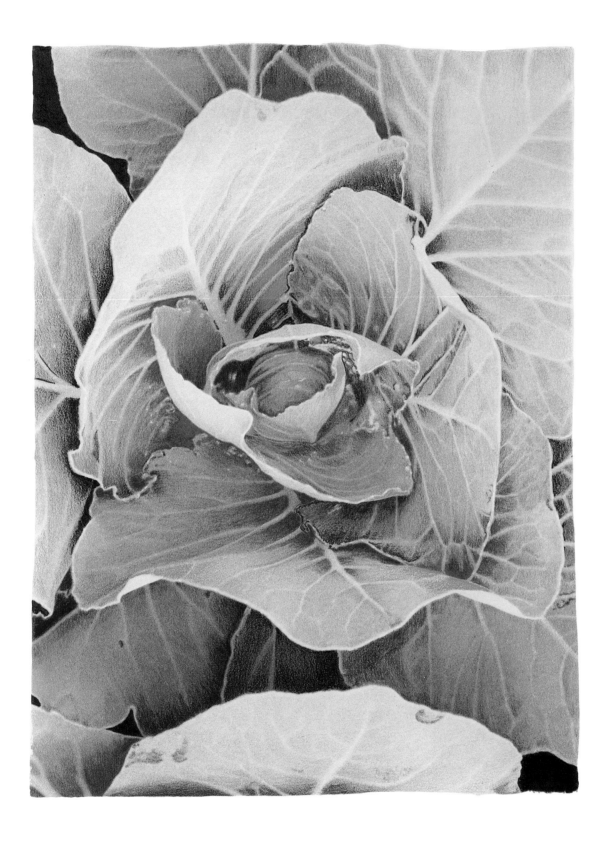

LINDA POVERMAN: *Cabbage II*, 1987

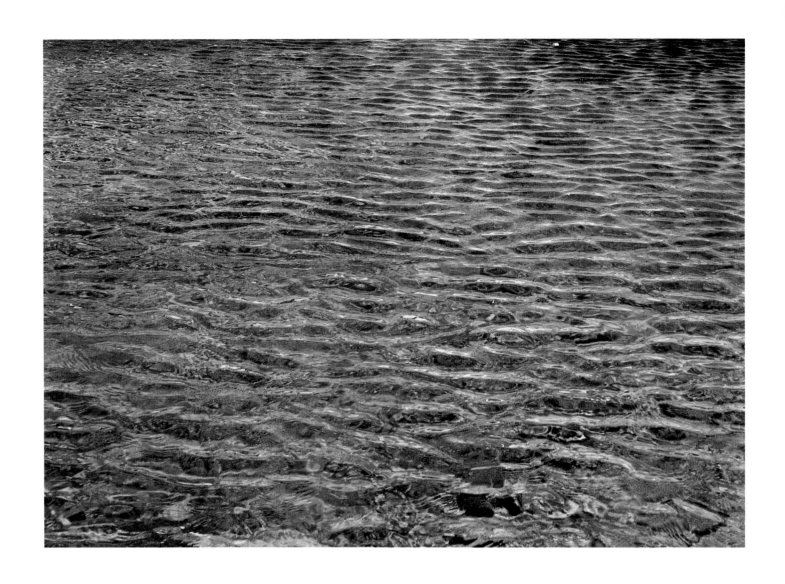

DANA SLAYMAKER: *Pond Surface, Sabino Canyon*, 1985/89

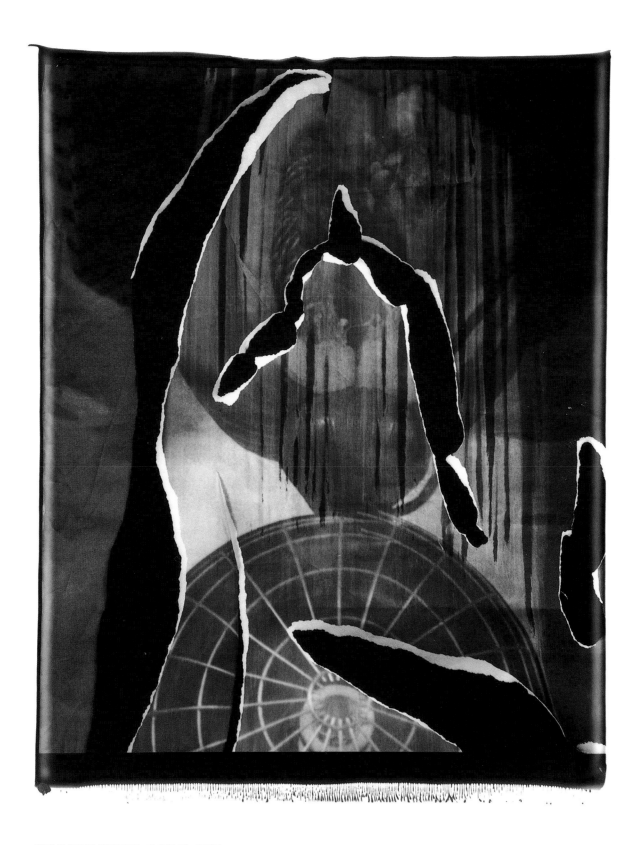

KENNETH SHORR: *Still Life*, 1987

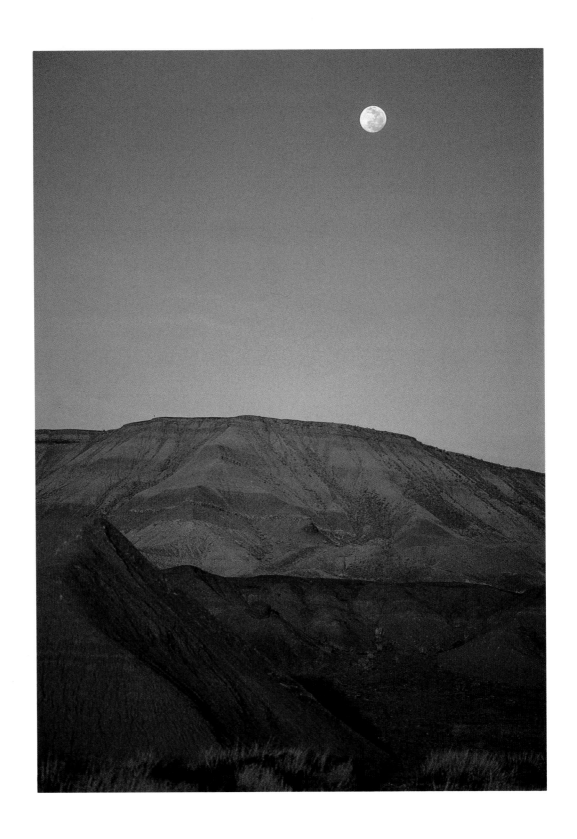

JAMES COWLIN: *Painted Desert Moonrise*

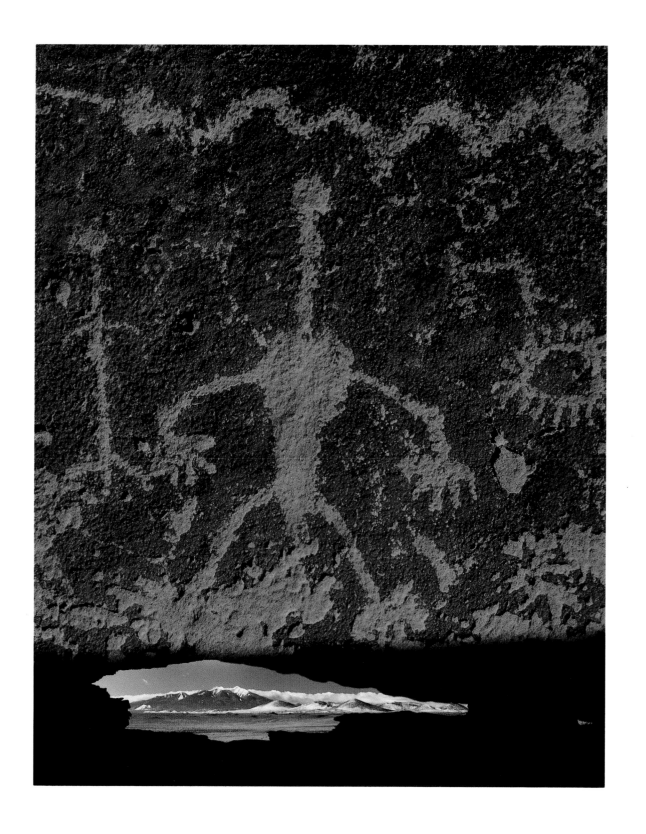

DAVID MUENCH: *Anasazi Petroglyph, San Francisco Peaks, Arizona,* 1978

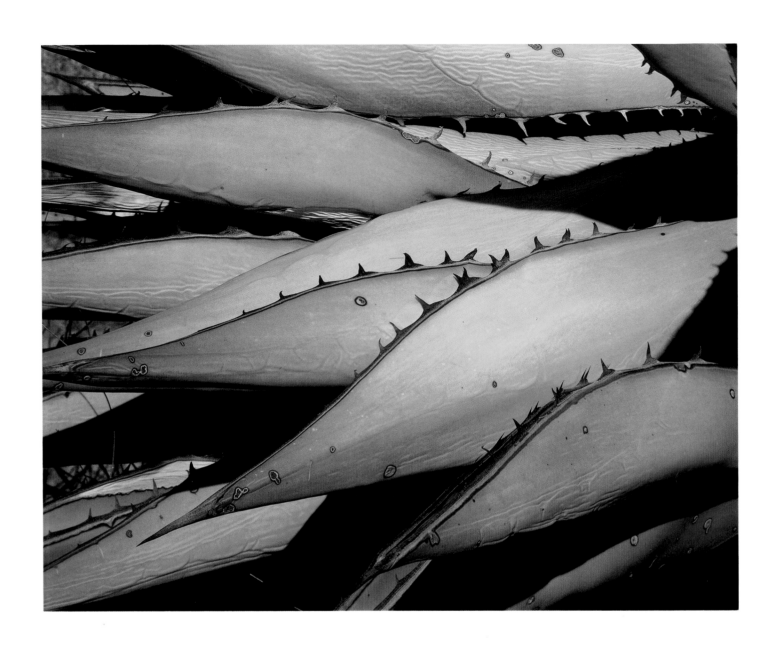

JACK DYKINGA: *Agave Leaves, Baja, Sierra San Borja, 1988*

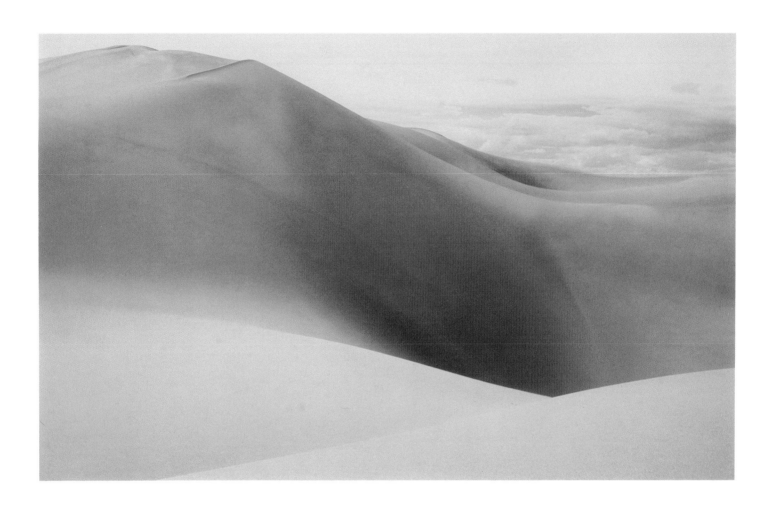

CHARLES BRAENDLE: *Great Sand Dunes, Colorado,* 1976

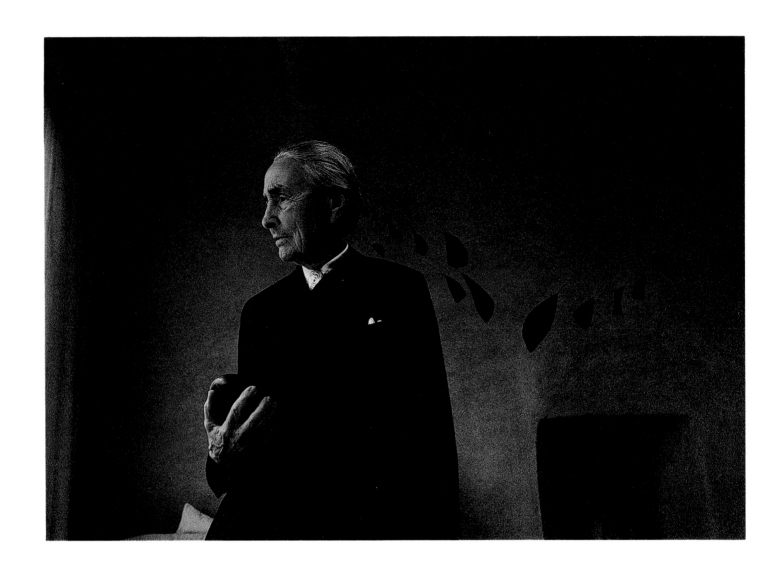

DAN BUDNIK: *Georgia O'Keeffe,* 1975

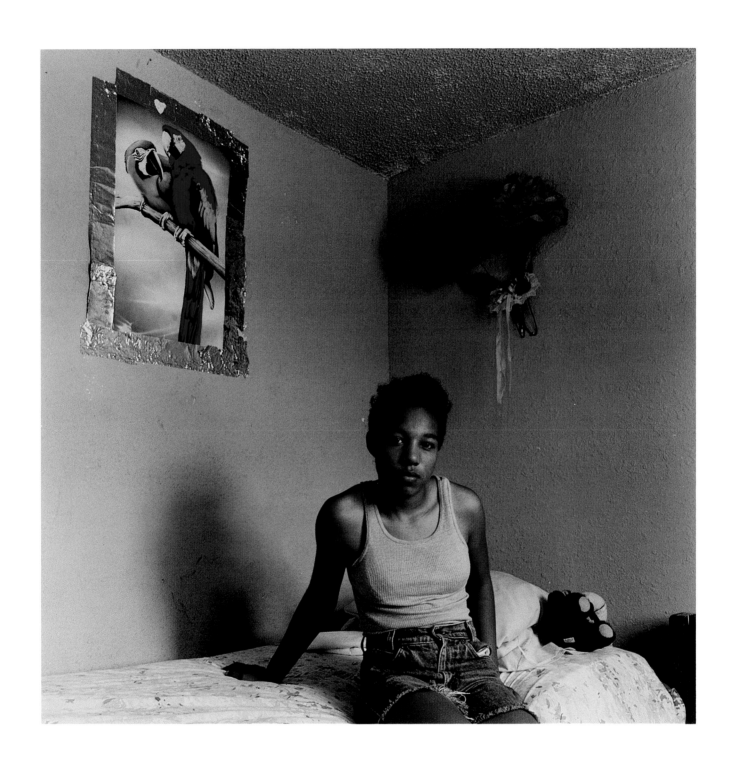

LOUIS CARLOS BERNAL: *Helen, Lubbock, Texas*, 1987

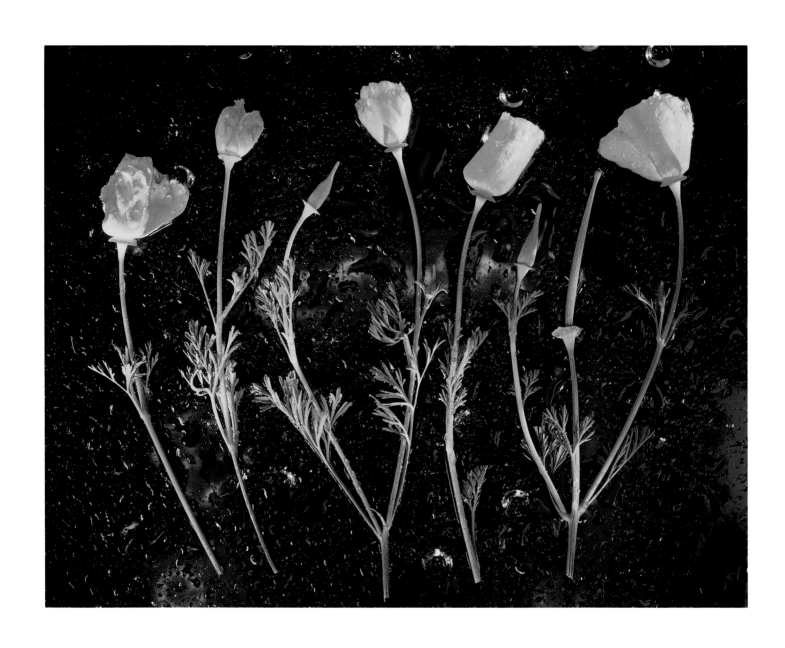

WILLIAM LESCH: *Poppies, Blue and Red*, 1988

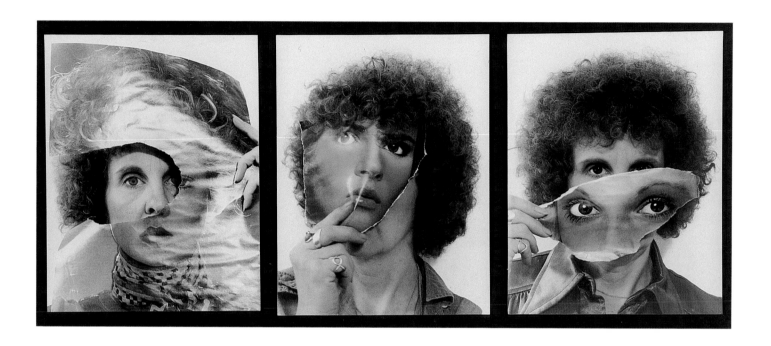

JUDITH GOLDEN: untitled (from the Magazine Series, 1975)

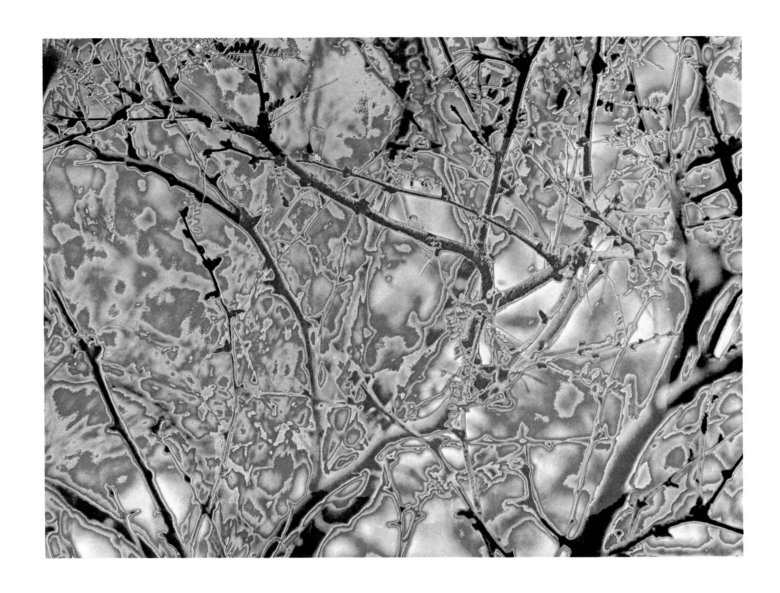

TODD WALKER: *Creosote and Sky*, 1980

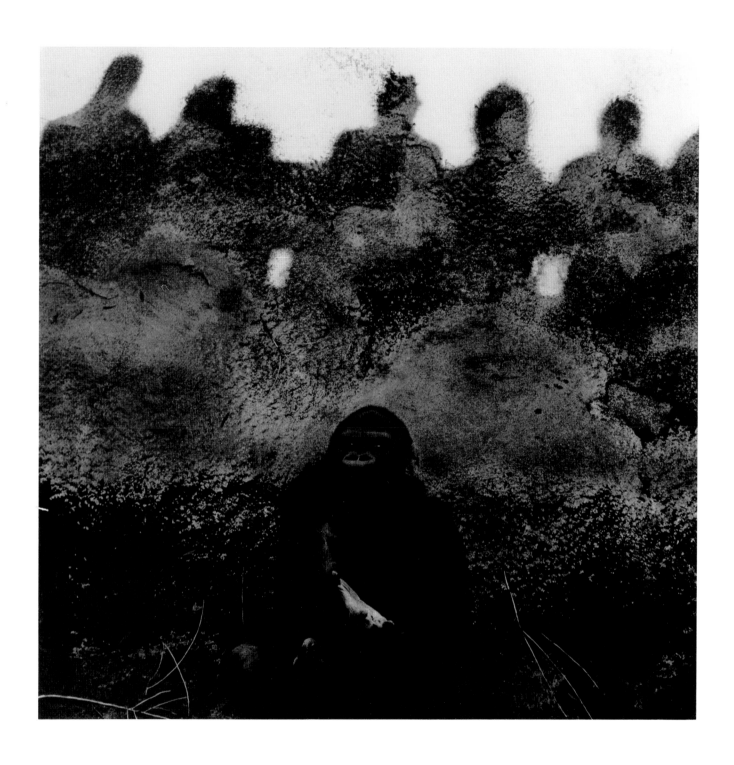

ERIC KRONENGOLD: untitled, 1969

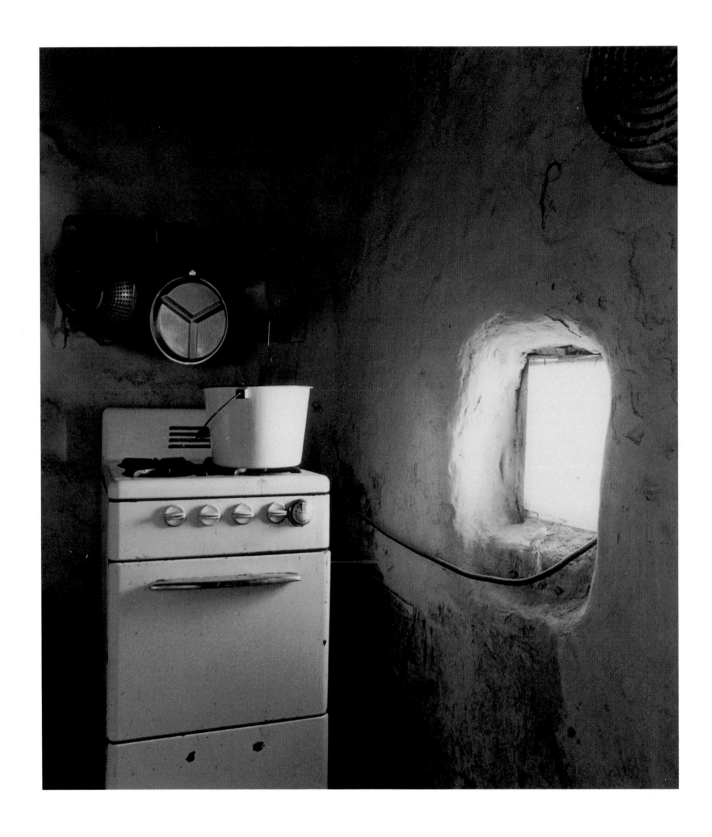

AL ABRAMS: *Propane Stove, Hopi, Second Mesa*, 1985

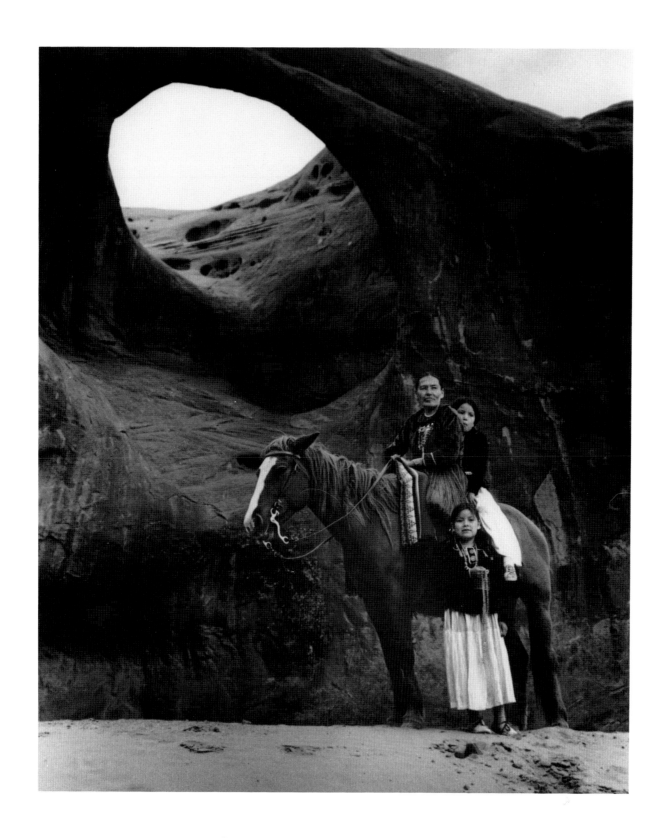

BARRY GOLDWATER: *Navajo Mother and Daughters*, 1948

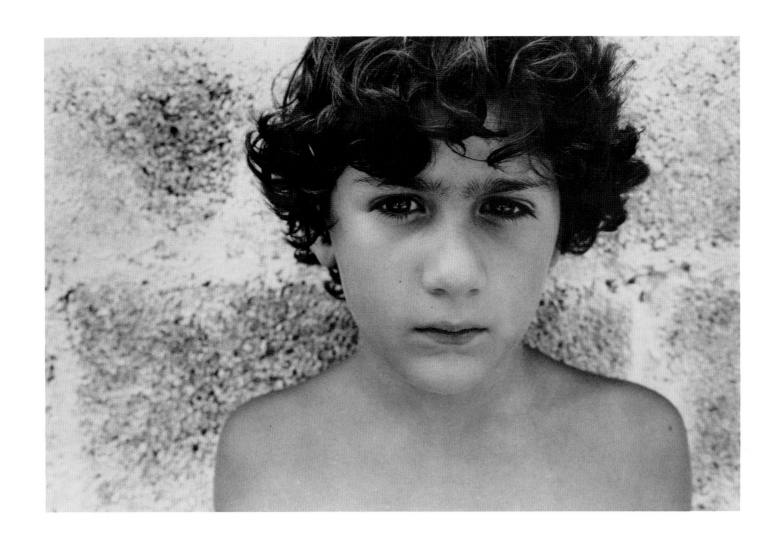

ROBERT BUITRÓN: *Joseph, Nuevo Laredo, Tamaulipas, Mexico,* 1980

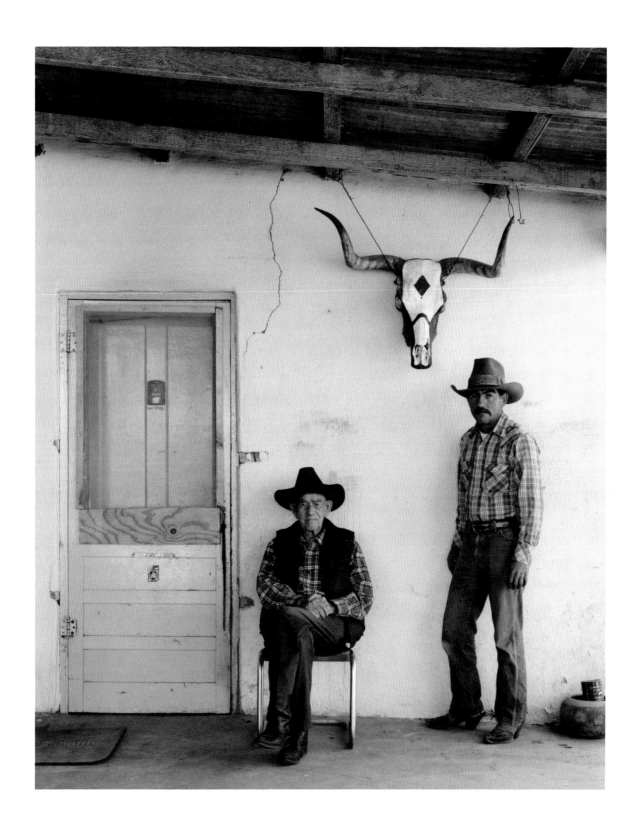

JAY DUSARD: *Rosamel and Ramon de la Ossa R Bar 9 Ranch, Lochiel, Arizona,* 1985

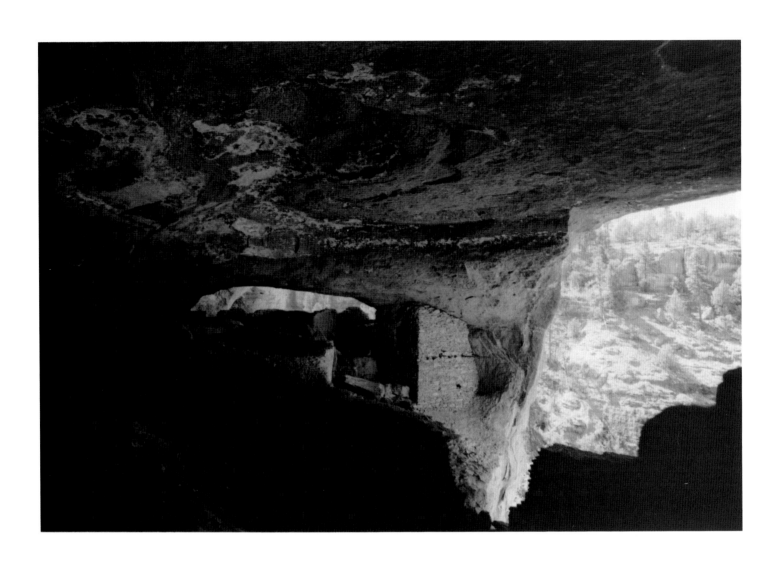

RUTHE MORAND: *Gila Cliff Dwellings, New Mexico,* 1982

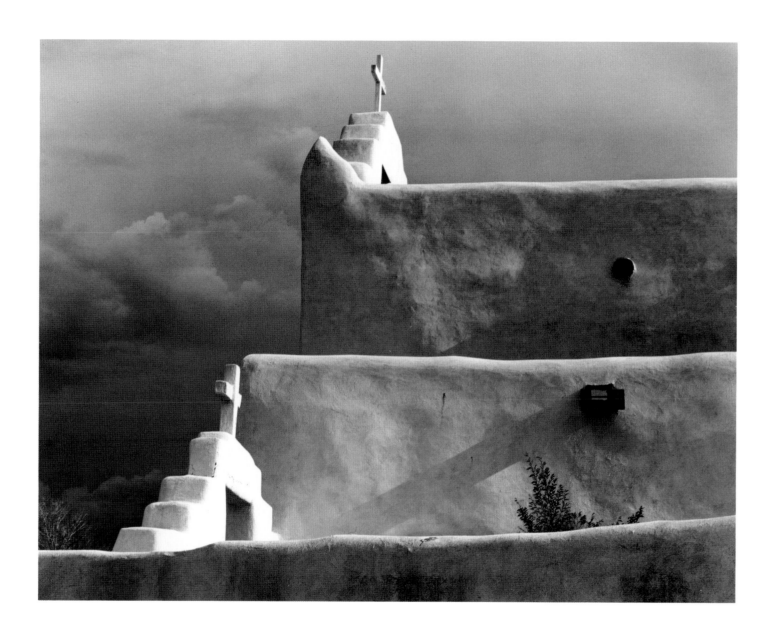

W. W. FULLER: *Church, Laguna Pueblo, New Mexico*, 1982

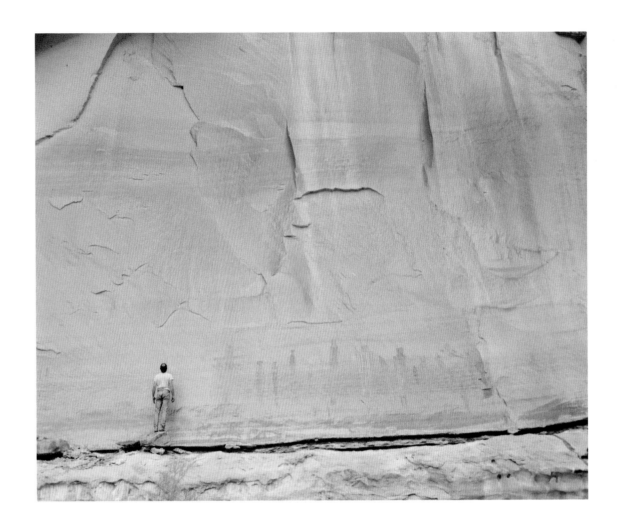

MICHAEL BERMAN: *Canyonlands, Utah*, 1987

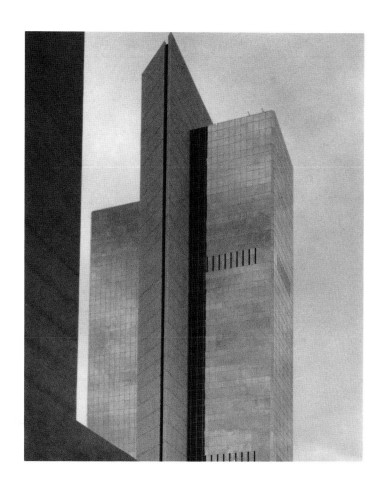

JEFFREY MATHIAS: *Valley National Bank Building — Phoenix*, 1987

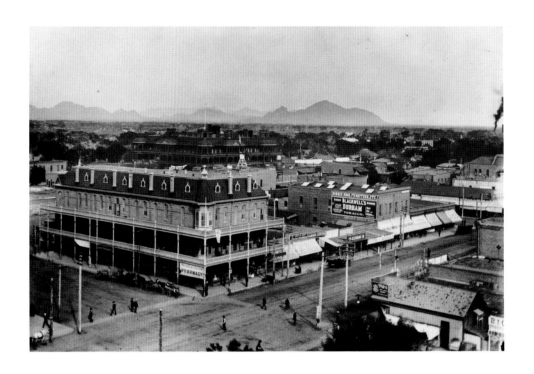

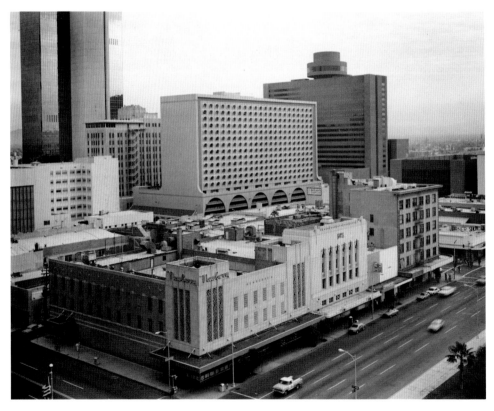

ALLEN DUTTON: *Northeast Corner Washington and First Avenue, Looking Northeast, 1982*

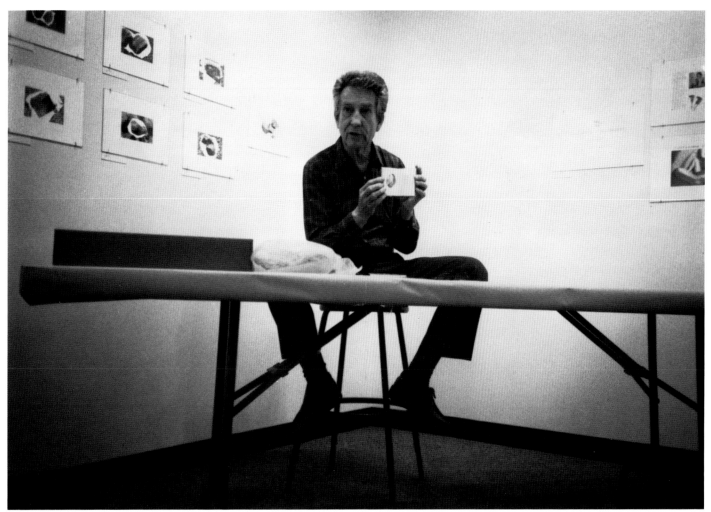

Todd Walker in Northlight Gallery showing students some of his early limited-edition books. The gallery was filled with his prints, a retrospective exhibition of his life's work from early automobile advertisements, through collotypes of nudes to highly complex (technically) color images of rocks. He's now retired and spends his days in printmaking experiments in Tucson. Personally I would like less craft and more passion.

BILL JAY: *Todd Walker, 1987*

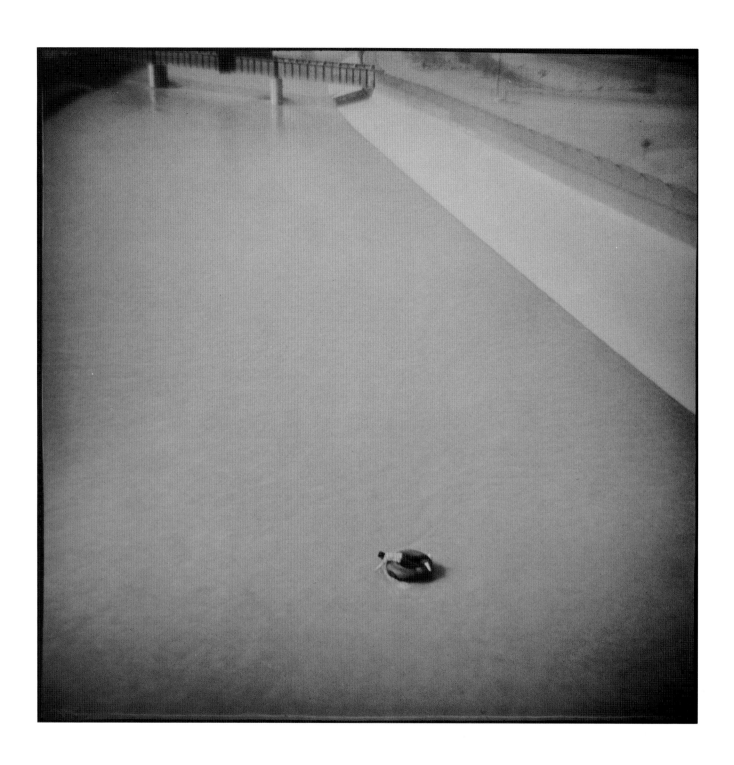

BARBARA GILSON: untitled, 1987

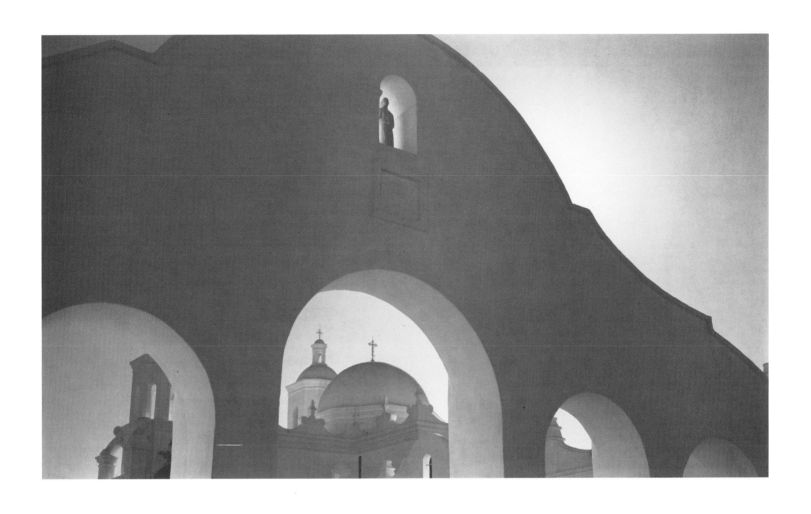

DICK ARENTZ: *Mission San Xavier del Bac, Arizona*, 1987

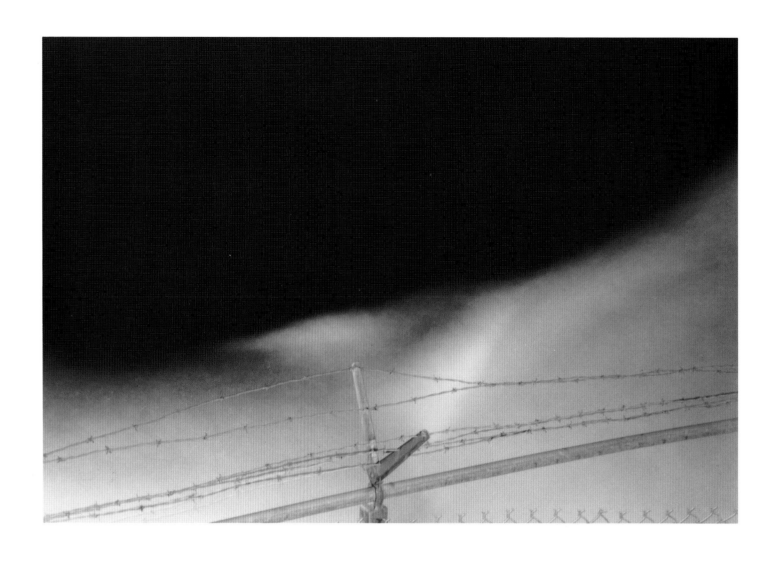

JAMES HAJICEK: untitled (from the To Fall in Darkness: Gifts of Suffering/Gifts of Rejoicing series, 1988)

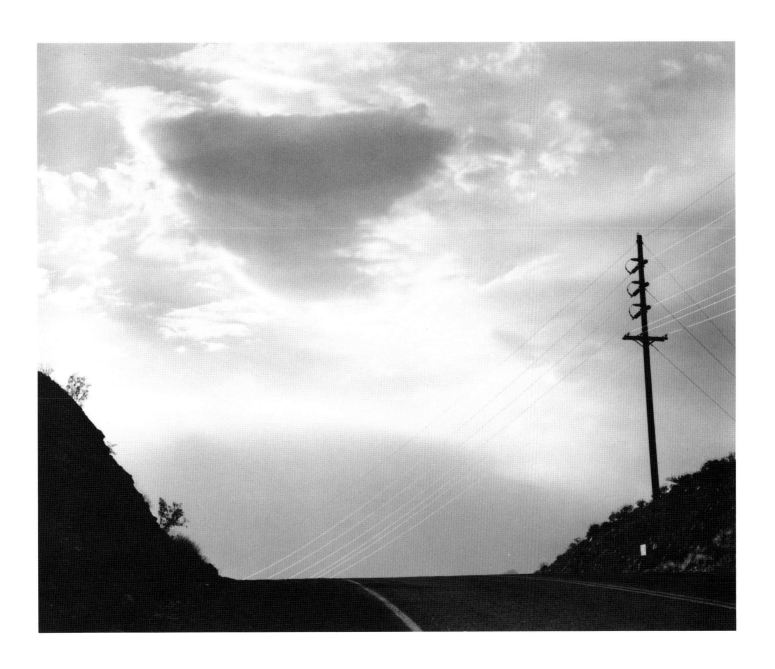

HAROLD JONES: *With Emmett*, 1978/86

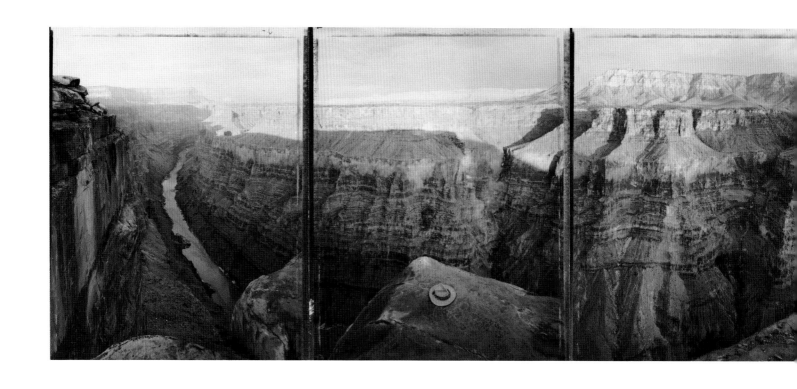

MARK KLETT: *Around Toroweap Point, Just Before and After Sundown, Beginning and Ending with View by J. K. Hillers, Over One Hundred Years Ago, Grand Canyon, 8/17/86*

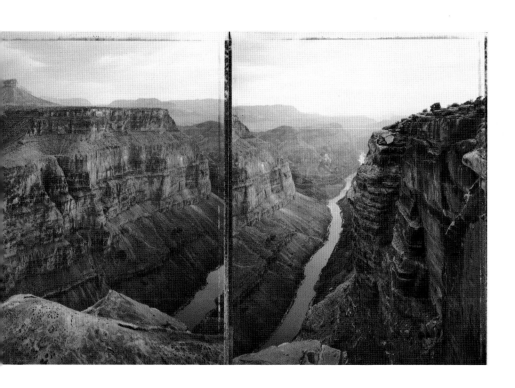

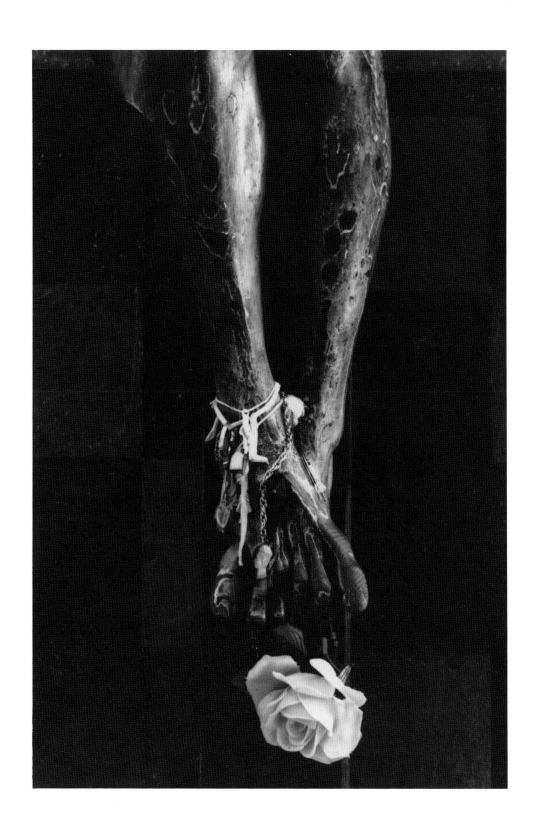

JOHN P. SCHAEFER: untitled

KEITH SCHREIBER: *Agave*, 1985

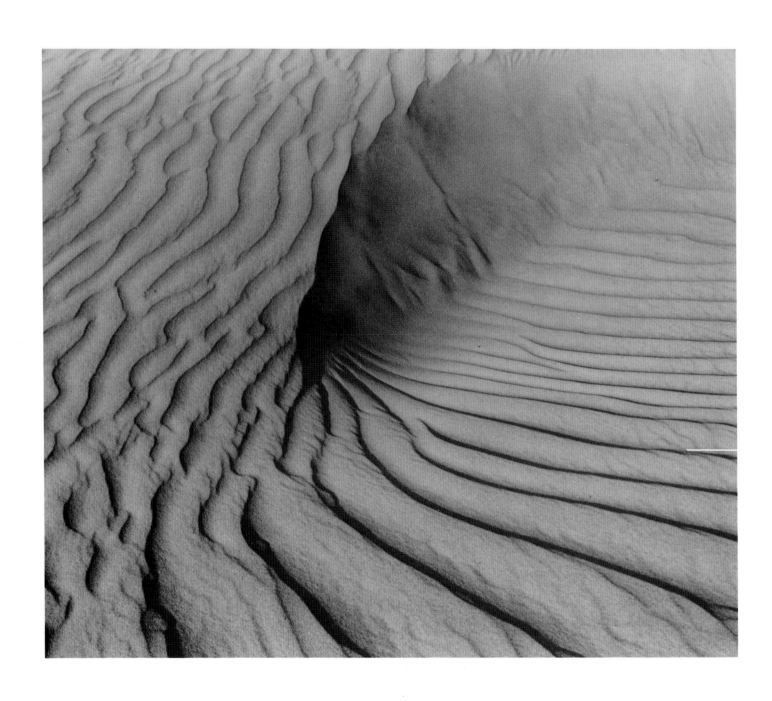

JOHN D. MERCER: *Sand Dunes, Death Valley, from Three Feet*, 1981

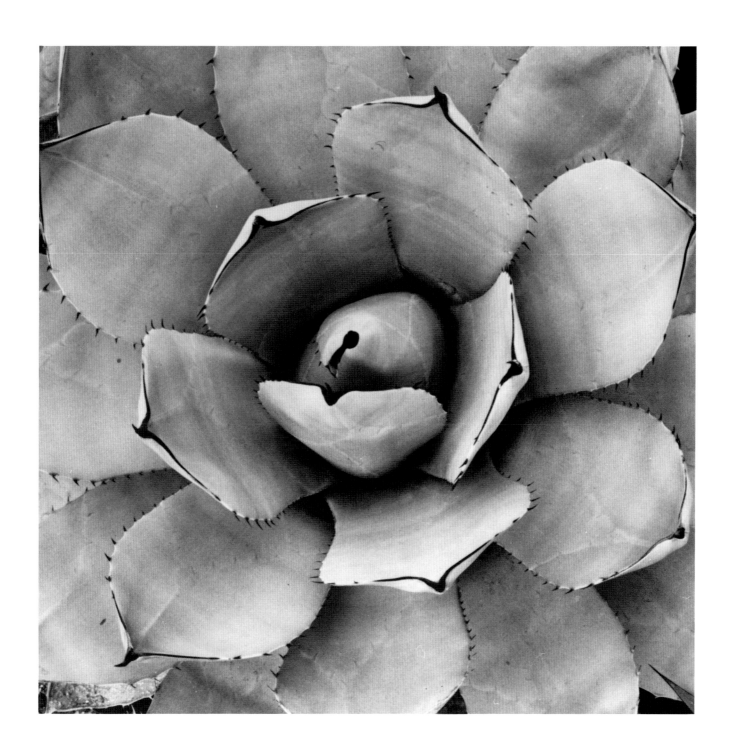

J. BARRY THOMSON: *Agave parryi* (from the From Out of the Desert series)

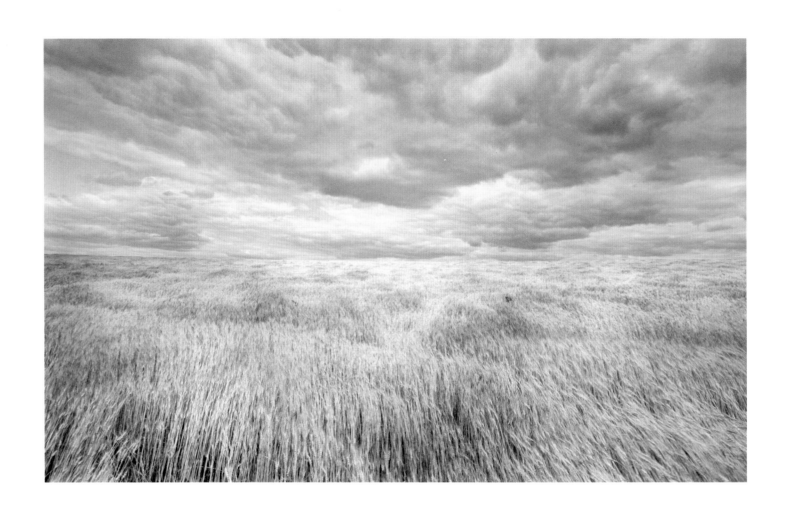

LAWRENCE McFARLAND: *Wheatfield,* 1976

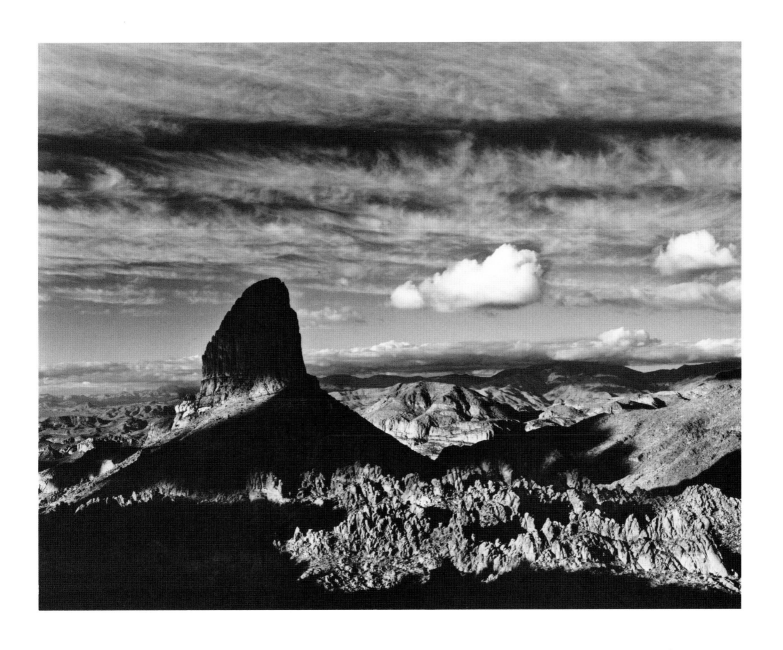

JODY FORSTER: *Weaver's Needle, Superstition Mountain, Arizona*, 1980/88

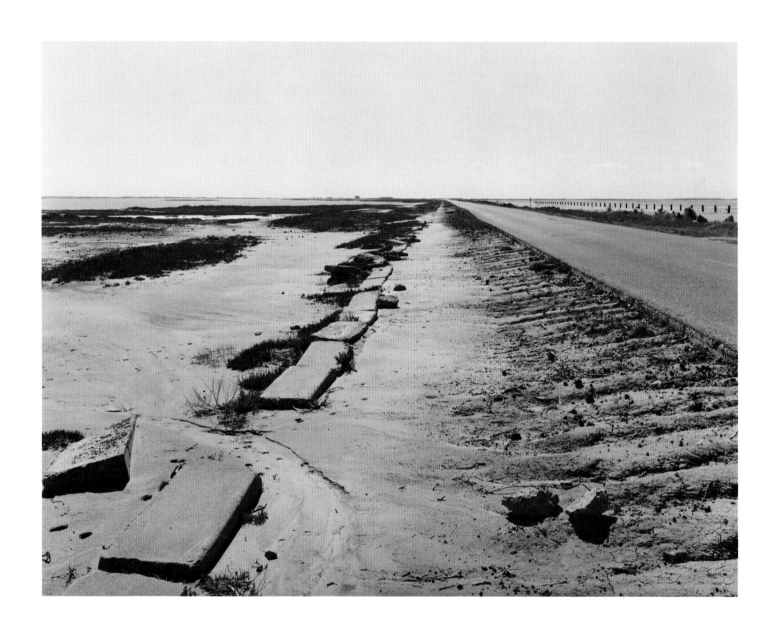

BILLY MOORE: *Boca Chica, Brownsville, Texas*, 1987

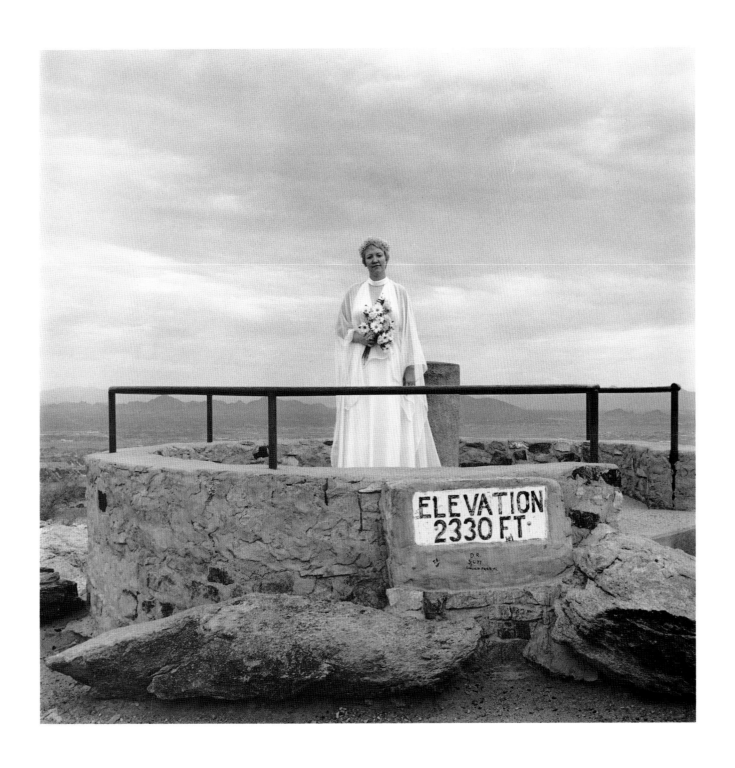

HAL MARTIN FOGEL: *Big Shirley on Her Wedding Day, South Mountain*, 1977/86

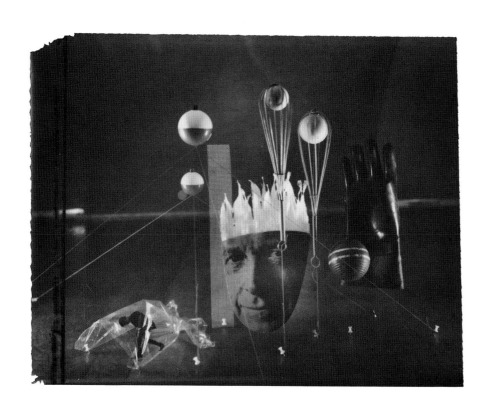

DAVID ELLIOTT: *King Caspar*, 1989

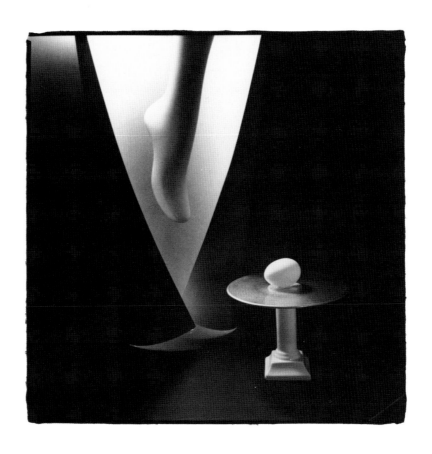

CAMILLE BONZANI: *Particular Moon-X*, 1988

FRANCES MURRAY: untitled (from the Dream Cards series, 1980)

CHECKLIST
OF THE
COLLECTION

*Photograph included in the Arizona
Commission on the Arts traveling
exhibition.

AL ABRAMS

Corey Ramon, Topowa, Arizona, Papago,
1978
Sepia-toned gelatin silver print,
20.3 x 15.9 cm
© 1978 Al Abrams

Pima Vet, Sacaton, Arizona, 1976
Sepia-toned gelatin silver print,
20.3 x 14.6 cm
© 1976 Al Abrams

Propane Stove, Hopi, Second Mesa, 1985*
Sepia-toned gelatin silver print,
20.3 x 17.8 cm
© 1985 Al Abrams

San Carlos Apache Woman, Peridot,
Arizona, 1973
Sepia-toned gelatin silver print,
20.3 x 15.2 cm
© 1973 Al Abrams

DICK ARENTZ

Alabama Hills, California, 1987
Platinum/palladium print,
27.9 x 47.9 cm
© 1987 Dick Arentz

Cholla, Joshua Tree National Monument,
California, 1985
Platinum/palladium print,
27.9 x 48.3 cm
© 1986 Dick Arentz

from the American Southwest portfolio:

Boulders, Vermillion Cliff Area,
Arizona, 1986
Platinum/palladium print,
27.9 x 48.3 cm
© 1987 Dick Arentz

Bryce Canyon, Utah, 1985
Platinum/palladium print,
28.3 x 48.9 cm
© 1985 Dick Arentz

Church, Rico, Colorado, 1986
Platinum/palladium print,
27.9 x 47.6 cm
© 1987 Dick Arentz

Gunnison Gorge, Rocky Mountains,
Colorado, 1986
Platinum/palladium print,
27.9 x 48.3 cm
© 1987 Dick Arentz

Mission San Xavier del Bac, Arizona,
1987*
Platinum/palladium print,
27.9 x 48.3 cm
© 1987 Dick Arentz

Mummy Cave Ruin, Canyon del Muerto,
Arizona, 1986
Platinum/palladium print,
27.9 x 48.3 cm
© 1987 Dick Arentz

Silverton, Colorado, 1986
Platinum/palladium print,
27.9 x 47.6 cm
© 1987 Dick Arentz

South of Hanksville, Utah, 1986
Platinum/palladium print,
27.9 x 48.3 cm
© 1987 Dick Arentz

Sunrise, Goblin Valley, Utah, 1986
Platinum/palladium print,
27.9 x 48.3 cm
© 1987 Dick Arentz

Superstition Mountains, Arizona, 1987
Platinum/palladium print,
27.9 x 48.3 cm
© 1987 Dick Arentz

Sycamores, Fish Creek, Arizona, 1987
Platinum/platinum print,
27.9 x 48.3 cm
© 1987 Dick Arentz

MICHAEL BERMAN

Canyonlands, Utah, 1987*
Gelatin silver print, 12.1 x 15.2 cm
© 1988 Michael Berman

Shadow Mountain, Utah, 1987
Gelatin silver print, 12.4 x 15.2 cm
© 1988 Michael Berman

LOUIS CARLOS BERNAL

Dos Mujeres, Douglas, Arizona, 1978*
Incorporated color coupler print,
35.6 x 35.6 cm
© 1978 Louis Carlos Bernal

Helen, Lubbock, Texas, 1987
Incorporated color coupler print,
35.6 x 35.6 cm
© 1990 Louis Carlos Bernal

CAMILLE BONZANI

Particular Moon-X, 1988
Gelatin silver print, 13.3 x 13.3 cm
© 1988 Camille Bonzani

CHARLES BRAENDLE

Great Sand Dunes, Colorado, 1976
Ektachrome print, 20.3 x 32.7 cm
© 1976 Charles Braendle

Great Sand Dunes, Colorado, 1978
Ektachrome print, 21.0 x 28.8 cm
© 1978 Charles Braendle

Great Sand Dunes, Colorado, 1983
Ektachrome print, 22.9 x 33.4 cm
© 1983 Charles Braendle

untitled [from the Grand Wheel
(Arizona State Fair) series]
Cibachrome print, 22.0 x 32.4 cm
© 1986 Charles Braendle

untitled [from the Grand Wheel
(Arizona State Fair) series]
Cibachrome diptych, 32.7 x 22.0 cm
each
© 1986 Charles Braendle

untitled [from the Grand Wheel
(Arizona State Fair) series]
Cibachrome diptych, 32.7 x 22.0 cm
each
© 1986 Charles Braendle

untitled [from the Grand Wheel
(Arizona State Fair) series]
Cibachrome diptych, 22.0 x 32.4 cm
each
© 1986 Charles Braendle

White Sands, New Mexico, 1983
Ektachrome print, 21.0 x 33.0 cm
© 1983 Charles Braendle

DAN BUDNIK

Georgia O'Keeffe, 1975★
Dye transfer print, 24.1 x 34.3 cm
© 1990 Dan Budnik

ROBERT BUITRÓN

Adolfo, Zapote de Peralta, Guanajuato, Mexico, 1979★
Gelatin silver print, 44.5 x 29.8 cm
© 1979 Robert Buitrón

Joseph, Nuevo Laredo, Tamaulipas, Mexico, 1980
Gelatin silver print, 30.5 x 45.1 cm
© 1980 Robert Buitrón

Las Verónicas, 1987
Gelatin silver print, 32.4 x 43.2 cm
© 1987 Robert Buitrón

JAMES COWLIN

Grand View Point Dawn★
Cibachrome print, 75.0 x 151.1 cm
© 1987 James Cowlin

Grandeur Point Dawn
Cibachrome print, 75.0 x 151.1 cm
© 1987 James Cowlin

Painted Desert Moonrise
Cibachrome print, 75.0 x 59.1 cm
© 1979 James Cowlin

JAY DUSARD

Casimiro Barrera, Cuidad Mier, Tamaulipas, 1985
Gelatin silver print, 48.9 x 38.8 cm
© 1985 Jay Dusard

Dona Crispina Gonzales vd. de Martínez curandera, Ojinaga, Chihuahua, 1985
Gelatin silver print, 48.9 x 38.8 cm
© 1985 Jay Dusard

Martin Black, Stampede Ranch, Nevada, 1982
Gelatin silver print, 38.8 x 48.3 cm
© 1982 Jay Dusard

Rosamel and Ramón de la Ossa R Bar 9 Ranch, Lochiel, Arizona, 1985★
Gelatin silver print, 48.9 x 39.4 cm
© 1985 Jay Dusard

ALLEN DUTTON

Northeast and Southeast Corners Central and Adams, Looking Northeast, 1985
Gelatin silver diptych, 26.7 x 33.7 cm each
© 1990 Allen Dutton

Northeast Corner Washington and First Avenue, Looking Northeast, 1982★
Gelatin silver diptych, 22.2 x 34.9 cm (top) and 26.0 x 34.9 cm (bottom)
© 1990 Allen Dutton

Northwest Corner First Street and Monroe, Looking Northwest, 1985
Gelatin silver print, 26.7 x 33.7 cm each
© 1990 Allen Dutton

Northwest Corner Washington and First Avenue, Looking North, 1984
Gelatin silver print, 22.2 x 34.9 cm (top) and 26.0 x 34.9 cm (bottom)
© 1990 Allen Dutton

JACK DYKINGA

Agave Leaves, Baja, Sierra San Borja, 1988★
Gelatin silver print, 49.5 x 61.0 cm
© 1988 Jack Dykinga

DAVID ELLIOTT

King Caspar, 1989
Gelatin silver print, 10.2 x 12.7 cm
© 1989 David Elliott

HAL MARTIN FOGEL

Big Shirley on Her Wedding Day, South Mountain, 1977/86★
Toned gelatin silver print, 35.2 x 35.6 cm
© 1990 Hal Martin Fogel

JODY FORSTER

Shiprock, New Mexico, 1979/89
Gelatin silver print, 50.2 x 39.4 cm
© 1990 Jody Forster

Weaver's Needle, Superstition Mountain, Arizona, 1980/88★
Gelatin silver print, 47.0 x 60.3 cm
© 1990 Jody Forster

W. W. FULLER

Church, Laguna Pueblo, New Mexico, 1982
Gelatin silver print, 19.1 x 23.7 cm
© 1990 W. W. Fuller

BARBARA GILSON

untitled, 1987 [child on inner tube in water]
Gelatin silver print,
© 1987 Barbara Gilson

untitled, 1987 [child on inner tube in water]
Gelatin silver print, 97.2 x 98.4 cm
© 1987 Barbara Gilson

untitled, 1987 [children running down sandy hill]
Gelatin silver print
© 1987 Barbara Gilson

untitled, 1987 [children running down sandy hill]★
Gelatin silver print, 96.9 x 97.8 cm
© 1987 Barbara Gilson

JUDITH GOLDEN

Persona XV, 1985★
Cibachrome print and mixed media, 59.7 x 49.5 cm
© 1985 Judith Golden

untitled (from the Magazine Series, 1975)
Hand-colored gelatin silver triptych, 35.0 x 27.6 cm each
© 1990 Judith Golden

untitled (from the Magazine Series, 1975)
Hand-colored gelatin silver triptych, 35.0 x 27.6 cm each
© 1990 Judith Golden

untitled (from the Magazine Series, 1975)
Hand-colored gelatin silver print, 34.3 x 27.0 (left), 35.0 x 27.3 cm (middle and right)
© 1990 Judith Golden

BARRY GOLDWATER

The Chief, 1938
Gelatin silver print, 35.0 x 27.3 cm
© 1938 Barry Goldwater

Grandmother Tall Salt, 1949
Gelatin silver print, 35.0 x 27.3 cm
© 1949 Barry Goldwater

Grandmother Yellow Salt, 1949
Gelatin silver print, 35.0 x 27.3 cm
© 1949 Barry Goldwater

Isabel One Salt, 1939
Gelatin silver print, 35.0 x 27.3 cm
© 1939 Barry Goldwater

Navajo Family, 1948
Gelatin silver print, 35.0 x 27.3 cm
© 1948 Barry Goldwater

Navajo Mother and Daughters, 1948★
Gelatin silver print, 35.0 x 27.3 cm
© 1948 Barry Goldwater

Navajo Pony, 1948
Gelatin silver print, 35.0 x 27.3 cm
© 1948 Barry Goldwater

Navajo Shepherdess, 1939
Gelatin silver print, 35.0 x 27.3 cm
© 1939 Barry Goldwater

The Old, 1949
Gelatin silver print, 35.0 x 27.3 cm
© 1949 Barry Goldwater

Sadie Church, 1948
Gelatin silver print, 35.0 x 27.3 cm
© 1948 Barry Goldwater

LORNE GREENBERG

Encounter, 1986★
Cibachrome print, 57.2 x 73.7 cm
© 1986 Lorne Greenberg

Wedding, 1986
Cibachrome print, 57.2 x 73.7 cm
© 1986 Lorne Greenberg

Windows of War, 1986
Cibachrome print, 57.2 x 73.7 cm
© 1986 Lorne Greenberg

JAMES HAJICEK

untitled (from the To Fall in Darkness:
 Gifts of Suffering/Gifts of Rejoicing
 series, 1988)★
Gelatin silver print, 31.8 x 47.0 cm
© 1988 James Hajicek

JERRY D. JACKA

*Solitude (Summer Storm near St. Johns,
 Arizona)*, 1984
Incorporated color coupler print,
 59.7 x 49.5 cm
© 1984 Jerry D. Jacka

Walpi Sunset (Hopi Reservation), 1974★
Incorporated color coupler print,
 59.7 x 90.2 cm
© 1974 Jerry D. Jacka

BILL JAY

Todd Walker, 1987
Gelatin silver print, 24.1 x 32.4 cm
© 1990 Bill Jay

HAROLD JONES

With Emmett, 1978/86★
Gelatin silver print, 43.8 x 54.0 cm

TAMARRA KAIDA

Best Friends (from the Fairy Tales series,
 1983)
Gelatin silver print, 34.3 x 43.2 cm
© 1983 Tamarra Kaida

Desert Paint, 1987★
Incorporated color coupler print,
 57.8 x 73.0 cm
© 1987 Tamarra Kaida

Escape (from the Fairy Tales series, 1983)
Gelatin silver print, 34.3 x 43.2 cm
© 1983 Tamarra Kaida

Gabriella (from the Fairy Tales series,
 1983)
Gelatin silver print, 34.3 x 43.2 cm
© 1983 Tamarra Kaida

Towards a New Social Documentary, 1987
Incorporated color coupler print,
 57.8 x 73.7 cm
© 1987 Tamarra Kaida

Worm of Doubt, 1987
Incorporated color coupler print,
 58.4 x 73.7 cm
© 1987 Tamarra Kaida

MARK KLETT

*Around Toroweap Point, Just Before and
 After Sundown, Beginning and Ending
 with View by J. K. Hillers, Over One
 Hundred Years Ago, Grand Canyon,
 8/17/86*
Gelatin silver polyptych, 50.2 x 40.0 cm
 each
© 1986 Mark Klett

*Balancing Rocks, Road to Lee's Ferry,
 Marble Canyon, Arizona, 5/10/86*★
Gelatin silver print, 50.8 x 40.6 cm each
© 1986 Mark Klett

ERIC KRONENGOLD

untitled, 1969 [gorilla in front of
 shadows on wall]
Gelatin silver print, 22.2 x 22.2 cm
© 1990 Eric Kronengold

JOE LABATE

Tucson, Arizona, 1986★
Incorporated color coupler print,
 37.5 x 56.5 cm
© 1990 Joe Labate

RITA LEE

The Pueblo — Carved Stairway, 1986★
Hand-colored gelatin silver print,
 47.0 x 33.7 cm
© 1986 Rita Lee

The Pueblo — Carved Stairway, 1986
Sepia-toned gelatin silver print,
 49.5 x 34.3 cm
© 1986 Rita Lee

The Pueblo — Pinnacle, 1986
Hand-colored gelatin silver print,
 37.2 x 47.0 cm
© 1986 Rita Lee

The Pueblo — Pinnacle, 1986
Sepia-toned gelatin silver print,
 37.2 x 47.0 cm
© 1986 Rita Lee

The Pueblo — Stepping Stones, 1986
Hand-colored gelatin silver print,
 48.6 x 35.0 cm
© 1986 Rita Lee

The Pueblo — Stepping Stones, 1986
Sepia-toned gelatin silver print,
 49.1 x 36.8 cm
© 1986 Rita Lee

WILLIAM LESCH

Amaryllis #7, 1988
Cibachrome print, 48.3 x 57.2 cm
© 1988 William Lesch

Blue Saguaro and Jupiter, 1988/88
Cibachrome print, 47.0 x 60.0 cm
© 1988 William Lesch

Green and Orange Saguaro and Clouds,
 1987/88
Cibachrome print, 59.7 x 47.0 cm
© 1987 William Lesch

Organ Pipe, Alamo Canyon, 1988/88
Cibachrome print, 47.0 x 60.3 cm
© 1988 William Lesch

Poppies, Blue and Red, 1988★
Cibachrome print, 47.0 x 59.7 cm
© 1988 William Lesch

Young Prickly Pear Pad, Blue/Red,
 1988/89
Cibachrome print, 55.9 x 46.4 cm
© 1988 William Lesch

ROXANNE MALONE

Geometric Series, #4, 1983
Kirlian photogram, Cibachrome print,
 43.0 x 38.7 cm
© 1985 Roxanne Malone

Geometric Series, #2, 1984
Kirlian photogram, Cibachrome print,
 48.9 x 38.7 cm
© 1985 Roxanne Malone

Geometric Series, #3, 1985★
Kirlian photogram, Cibachrome print,
 48.9 x 38.7 cm
© 1985 Roxanne Malone

JEFFREY MATHIAS

Valley National Bank Building — Phoenix,
 1987★
Platinum/palladium print, 11.4 x 9.5 cm
© 1987 Jeffrey Mathias

Security Building — Phoenix, 1987
Platinum/palladium print, 11.4 x 9.2 cm
© 1987 Jeffrey Mathias

LAWRENCE McFARLAND

Wheatfield, 1976
Gelatin silver print, 26.0 x 42.5 cm
© 1990 Lawrence McFarland

White Sands, New Mexico, 1981
Gelatin silver print, 26.0 x 42.5 cm
© 1990 Lawrence McFarland

JOHN D. MERCER

Frosted Weed, Cave Creek, 1985★
Gelatin silver diptych, 22.9 x 47.0 cm
 each
© 1990 John D. Mercer

*Sand Dunes, Death Valley, from Three
 Feet*, 1981
Gelatin silver polyptych, 25.1 x 29.4 cm
 each
© 1990 John D. Mercer

Storm and Sand Dunes, Death Valley, 1982
Gelatin silver print, 34.3 x 47.0 cm
© 1990 John D. Mercer

BILLY MOORE

Boca Chica, Brownsville, Texas, 1987
Gelatin silver print, 33.7 x 43.8 cm
© 1990 Billy Moore

RUTHE MORAND

Gila Cliff Dwellings, New Mexico, 1982★
Gelatin silver print, 29.2 x 43.2 cm
© 1990 Ruthe Morand

*Petroglyphs, Zuni Indian Reservation,
 New Mexico*, 1985
Gelatin silver print, 43.2 x 28.6 cm
© 1990 Ruthe Morand

DAVID MUENCH

*Anasazi Petroglyph, San Francisco Peaks,
 Arizona*, 1978★
Incorporated color coupler print,
 50.2 x 40.0 cm
© 1981 David Muench

*Cinder Cone, Lassen National Park,
 California*, 1973
Incorporated color coupler print,
 40.0 x 50.2 cm
© 1981 David Muench

FRANCES MURRAY

untitled (from the Dream Cards series,
 1980)★
Gelatin silver print, 35.0 x 35.0 cm
© 1980 Frances Murray

untitled (from the Dream Cards series,
 1980)
Gelatin silver print, 35.0 x 35.2 cm
© 1980 Frances Murray

LINDA POVERMAN

B II, 1987
Van dyke print with prisma color,
 32.4 x 48.3 cm
© 1990 Linda Poverman

Cabbage II, 1987★
Van dyke print with prisma color,
 48.3 x 36.8 cm
© 1990 Linda Poverman

JOHN RUNNING

Teepees — Rocky Boys, Montana, 1978/88
Cibachrome print, 48.3 x 73.7 cm
© 1985 John Running

JOHN P. SCHAEFER

from the Bac: Where the Waters Gather
portfolio

untitled [baptistry]
Gelatin silver print, 17.8 x 12.1 cm
© 1978 John P. Schaefer

untitled [Blessed Virgin]
Gelatin silver print, 17.1 x 10.8 cm
© 1978 John P. Schaefer

untitled [crucifix]
Gelatin silver print, 17.8 x 12.1 cm
© 1978 John P. Schaefer

untitled [dome seen through arches]
Gelatin silver print, 17.4 x 13.3 cm
© 1978 John P. Schaefer

untitled [door handle]
Gelatin silver print, 16.8 x 13.3 cm
© 1978 John P. Schaefer

untitled [from view of San Xavier]
Gelatin silver print, 14.3 x 18.4 cm
© 1978 John P. Schaefer

untitled [Jesus Christ in baptistry]
Gelatin silver print, 15.6 x 10.2 cm
© 1978 John P. Schaefer

untitled [mission from courtyard]
Gelatin silver print, 13.5 x 17.1 cm
© 1978 John P. Schaefer

untitled [St. Anthony of Padua]
Gelatin silver print, 18.1 x 13.3 cm
© 1978 John P. Schaefer

untitled [St. Joseph]
Gelatin silver print, 18.4 x 10.8 cm
© 1978 John P. Schaefer

untitled [San Xavier]
Gelatin silver print, 17.1 x 12.1 cm
© 1978 John P. Schaefer

untitled [Sorrowing Mother]
Gelatin silver print, 16.8 x 10.8 cm
© 1978 John P. Schaefer

untitled [station of the cross]
Gelatin silver print, 15.2 x 19.7 cm
© 1978 John P. Schaefer

untitled [wooden legs with flower at
feet]
Gelatin silver print, 19.1 x 12.7 cm
© 1978 John P. Schaefer

KEITH SCHREIBER

Agave, 1985
Gelatin silver print, 45.1 x 29.8 cm
© 1987 Keith Schreiber

KENNETH SHORR

Still Life, 1987★
Polaroid print, 68.6 x 55.9 cm
© 1990 Kenneth Shorr

ANN SIMMONS-MYERS

Koi, 1987★
Gum bichromate triptych, 15.2 x 55.9 cm
each
© 1987 Ann Simmons-Myers

Minnow, 1988
Gum bichromate diptych, 49.5 x 39.4 cm
each
© 1988 Ann Simmons-Myers

DANA SLAYMAKER

Pond Surface, Sabino Canyon, 1985/89★
Cibachrome print, 69.9 x 99.1 cm
© 1990 Dana Slaymaker

J. BARRY THOMSON

Agave parryi (from the From Out of the
Desert series)★
Gelatin silver print, 24.1 x 24.8 cm
© 1990 J. Barry Thomson

Branch and Reeds, Boston
Gelatin silver print, 19.7 x 18.4 cm
© 1990 J. Barry Thomson

Echinopsis, Phoenix (from the From Out
of the Desert series)
Gelatin silver print, 22.9 x 29.2 cm
© 1990 J. Barry Thomson

*Grasses, Mount Washington,
New Hampshire*
Gelatin silver print, 22.2 x 32.4 cm
© 1990 J. Barry Thomson

Hillside, Charlotte, Vermont
Gelatin silver print, 24.1 x 24.8 cm
© 1990 J. Barry Thomson

Mammillaria albicans (from the From
Out of the Desert series)
Gelatin silver print, 25.7 x 25.1 cm
© 1990 J. Barry Thomson

Reeds, Lake Champlain, Vermont
Gelatin silver print, 29.2 x 46.4 cm
© 1990 J. Barry Thomson

untitled (from the From Out of the
Desert series)
Gelatin silver print, 22.9 x 28.3 cm
© 1990 J. Barry Thomson

untitled (from the From Out of the
Desert series)
Gelatin silver print, 27.9 x 25.4 cm
© 1990 J. Barry Thomson

untitled (from the From Out of the
Desert series)
Gelatin silver print, 27.9 x 24.8 cm
© 1990 J. Barry Thomson

TODD WALKER

Apologies to Mondrian, 1981
Photographic offset lithograph,
19.1 x 26.7 cm
© 1990 Todd Walker

Creosote and Sky, 1980
Photographic offset lithograph,
19.1 x 26.7 cm
© 1990 Todd Walker

Erosion II, 1981
Photographic offset lithograph,
19.1 x 26.7 cm
© 1990 Todd Walker

To Linda Connor, 1973
Photographic silkscreen, 36.8 x 46.4 cm
© 1990 Todd Walker

untitled, 1981 [landscape]★
Photographic offset lithograph,
26.7 x 19.1 cm
© 1990 Todd Walker